CHINESE
WATERCOLOUR TECHNIQUES
Painting Animals

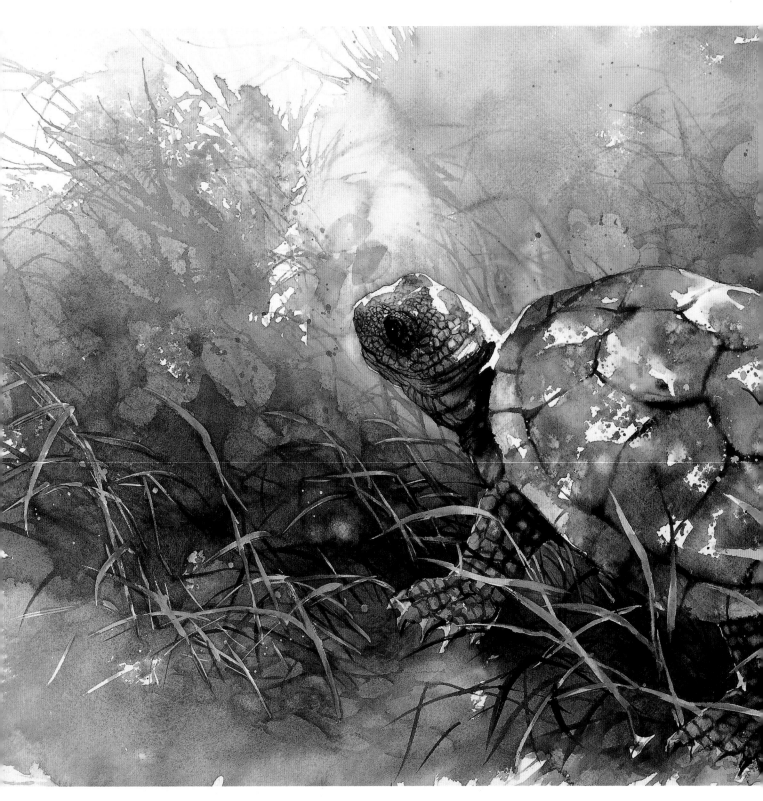

TURTLE *Watercolor* *14"× 26" (36cm × 66cm)* *140-lb. (300gsm) cold-pressed watercolor paper*

CHINESE
WATERCOLOUR TECHNIQUES
Painting Animals

Lian Quan Zhen

David & Charles

About the Author

Lian Zhen was born in Canton, China. He started sketching and painting when he was ten years old. He was a physician in his hometown until 1985, when he immigrated to the United States. He received a Bachelor of Arts from the University of California at Berkeley in 1992 and his Masters degree in Architecture from MIT in 1996.

He has had many solo shows in the US, Hong Kong and China, and has developed an international following. His paintings hang in numerous institutions and private collections including the MIT museum, which has collected fourteen of his paintings.

Lian has received many awards such as the 1997 and 1998 International Animal in Arts Competition. His art teaching experience includes eight years at the University of California at Berkeley, where he taught watercolor outdoor sketching. He also teaches watercolor and Chinese painting workshops internationally. Besides being an invited juror for many art shows, his paintings have also been published in the following books: *Watercolor 94 Spring*, *Splash 4*, the *Collectors* (Hong Kong) and *Landscape in Watercolor* (UK). His first book: *Chinese Painting Techniques for Exquisite Watercolors* was published by North Light Books in October 2000; it was the February 2001 main selection book for North Light Book Club.

For more information on his paintings and workshops, see his website www.lianspainting.com and send email to lianzhen@yahoo.com, or write to Lian Zhen, P.O. Box 33142, Reno, NV 89532.

A DAVID & CHARLES BOOK

David & Charles is a subsidiary of F+W (UK) Ltd.,
an F+W Publications Inc. company

First published in the UK in 2004

Copyright © Lian Quan Zhen 2004

Lian Quan Zhen has asserted his right to be identified as author of this work in accordance with the Copyright, Designs and Patents Act, 1988.

A catalogue record for this book is available from the British Library.

ISBN 0 7153 2048 3 hardback

Printed in China by SNP-Leefung
for David & Charles
Brunel House Newton Abbot Devon

Visit our website at www.davidandcharles.co.uk

David & Charles books are available from all good bookshops; alternatively you can contact our Orderline on (0)1626 334555 or write to us at FREEPOST EX2 110, David & Charles Direct, Newton Abbot, TQ12 4ZZ (no stamp required UK mainland).

Edited by Christina Xenos
Designed by Wendy Dunning
Interior layout by Jessica Schultz
Production coordinated by Mark Griffin

METRIC CONVERSION CHART

To convert	to	multiply by
Inches	Centimetres	2.54
Centimetres	Inches	0.4
Feet	Centimetres	30.5
Centimetres	Feet	0.03
Yards	Metres	0.9
Metres	Yards	1.1
Sq. Inches	Sq. Centimetres	6.45
Sq. Centimetres	Sq. Inches	0.16
Sq. Feet	Sq. Metres	0.09
Sq. Metres	Sq. Feet	10.8
Sq. Yards	Sq. Metres	0.8
Sq. Metres	Sq. Yards	1.2
Pounds	Kilograms	0.45
Kilograms	Pounds	2.2
Ounces	Grams	28.3
Grams	Ounces	0.035

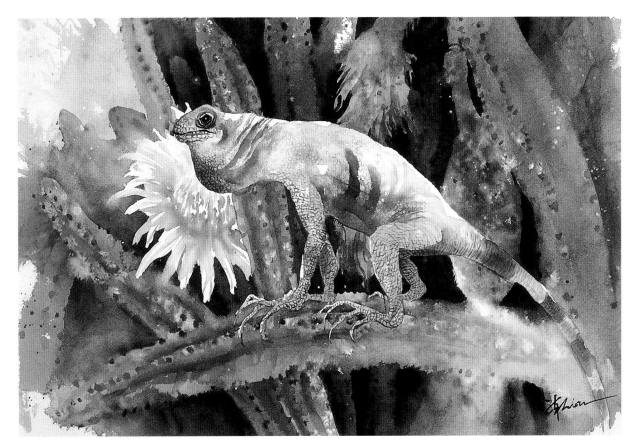

LIZARD *Watercolor 14″ × 22″ (36cm × 56cm) 140-lb. (300gsm) cold-pressed watercolor paper*

Acknowledgments

Many thanks to: Rachel Wolf for making this book possible through North Light Books; Christina Xenos, the editor of this book, who makes my writing easy to understand; Joyce and James Estes, who let me use their great collections of animal samples; Nancy and Bob Terrebonne, who allowed me to stay in their home when I was writing the first three chapters of this book; to many of my other friends who have been helping me in my art journey.

Dedication

To Yiling Zhang, my best friend, my soulmate, my spiritual and life companion.

I wish my mom could see this book and my paintings. I believe she is watching over me and is proud of what I am doing.

TABLE OF CONTENTS

1 MATERIALS & BASIC TECHNIQUES

page 12

Compare Chinese brush painting materials with those used in traditional watercolor. Learn to arrange your work areas. Practice loading and using the Chinese brush.

2 COMPOSITION

page 28

Discover organization techniques to create the best composition for your painting. Enhance your subjects with color and value. Find the soul of your painting: the focal point.

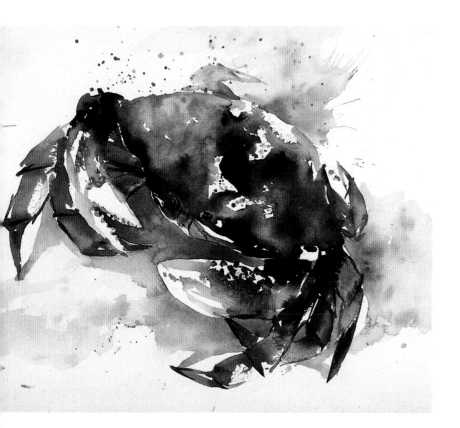

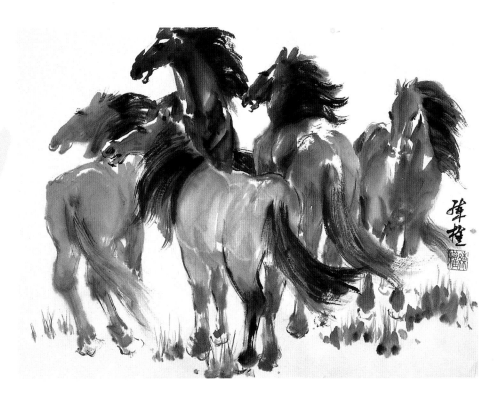

Learn how to stretch and mount your Chinese painting step-by-step. 120

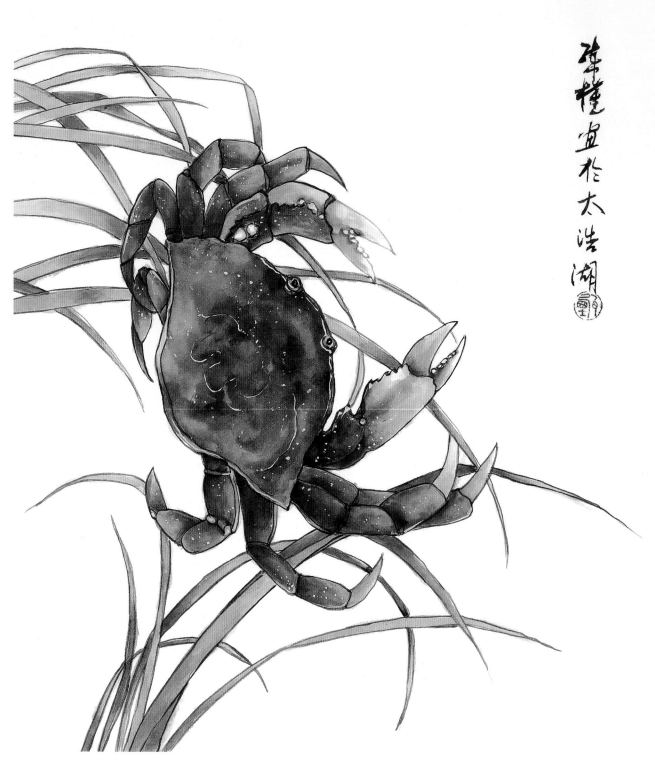

草橙宜於太浩湖

CRAB 12" × 16" (30cm × 41cm) Chinese ink and colors on mature Shuan paper

Introduction

When creating Chinese paintings, artists do not call it *painting*, they call it *writing*. In Chinese painting, subjects are painted with a variety of strokes: short, long, thick, wide, dry, wet, light, heavy, or a combination of them. Chinese calligraphy is done with the same kind of strokes; in fact, you can consider calligraphy a type of abstract art.

Capturing the essence and spirit of a subject rather than merely copying its nature is essential in Chinese painting. When an artist paints an animal, he or she focuses on *writing*, to capture the life of the animal without imitating the unnecessary details. As a result, when you see an animal in a painting it does not *look* like an animal, but you *feel* it as an animal. Some watercolor paintings merely tend to illustrate objects and in doing so lose the *life* of them.

This book shows my experiments in Chinese and watercolor techniques: the Eastern and Western arts blending into each other to capture the essence of animals. Throughout the following lessons, I will teach you to *write* animals on your paintings as if they are moving, acting, flying and singing.

DEVELOPMENT OF CHINESE ANIMAL PAINTING

Animals as subjects appeared on Chinese paintings dating back to the Tang Dynasty, about 1,300 years ago. One typical example from that period is *Five Cows* painted by Han-Fung (A.D. 723-787). The artist painted five cows on paper in five different positions. He painted them in detail style by first outlining the cows with ink and then applying multiple layers of colors. Back then it was common to create animal paintings in detail style. This was true for several centuries.

Later, animal paintings became looser in detail, focusing more on capturing the essence of the animals. The figures on this page are examples of cow paintings I copied from artists of three different dynasties. They show the development of Chinese animal painting: from detail style, illustrating a realistic representation of the animals, to spontaneous style, emphasizing the spirits of the animals.

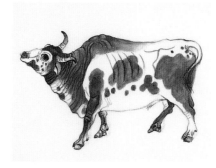

This is a re-creation of one of the *Five Cows* painted by the Tang Dynasty artist Han-Fung. He was a high-ranking officer who loved rural life and visited villages often. He was familiar with animals such as cows so he painted them in the correct proportion and with accurate colors, yet not as stiff as the animals painted before his time.

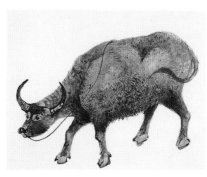

This cow is painted in the style of Mao-Yi during the Sung Dynasty (A.D. 960-1280). Compared to Han-Fung, he emphasized motion by using a variety of strokes.

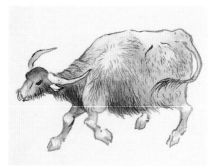

This cow is painted in the style of Yong-Jun during the Ching Dynasty (A.D. 1644-1912). His painting started mimicking the spirit of the animal. He used much less detail and simpler strokes.

These two cows illustrate *spontaneous-style* painting—the cows don't really *look* like cows; rather, you *feel* that they are cows. Chi Pai-shih and Chang Dai-chien, two great modern masters who lived in the twentieth century, painted cows in this way with minimum strokes. You can't see that many details on their cows. You only notice the essence of the animals: the important features, overall shape and motion.

DEVELOPMENT OF CHINESE CHARACTERS

One interesting comparison to draw in Chinese technique is between the development of Chinese animal painting and the evolution of Chinese characters. In Chinese history, most of the characters evolved from complicated pictographs to simple and abstract modern forms. About 16,000 years ago, the Chinese created their writing through observing and interpreting nature. The original forms were the simplified sketches depicting nature and objects.

This page illustrates examples of such characters for animals. Every one of them has five different forms from different time periods. From left to right they are:

Shell and Bone Character from the Shang Dynasty (1,500-1,050 B.C.), inscriptions were carved on oracle bones with practical and angular strokes.

Bronze Character Shang and Zhou Dynasties (up to 771 B.C.), inscriptions were painted on bronze vessels. The strokes are smooth but forceful.

Ancient Character from Warring States Period (475-221 B.C.), inscriptions found on surfaces of bamboo, stone, pottery and seals.

Seal Character from Qin Dynasty (221-207 B.C.). Its emperor was Chin-Shih-Huang-Ti, who united China for the first time and was buried with the terracotta army. He contributed to standardized Chinese characters. This was the official written form then.

Modern Character These characters are the present written form. They are very simple and abstract, similar to the cows painted by the two modern artists.

This shows the evolution of the character *cow*. The first four look like the front view of a cow showing the head and the horns.

This is the character of *elephant*. In prehistoric times, there were many elephants in northern China. Notice how the first character just looks like a profile of the animal.

In the *tiger* character the first and second characters are the sketches of the animal. The later characters moved away from the real shape and became abstract.

The first two characters of the *dog* are profiles of dogs. The later characters lost the traces of the earlier images. The dot on the upper right of the modern character is probably a dog's ear.

The characters of the *horse* are the profile of a standing horse. The upper part represents the animal's face, eye and mane.

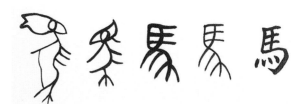

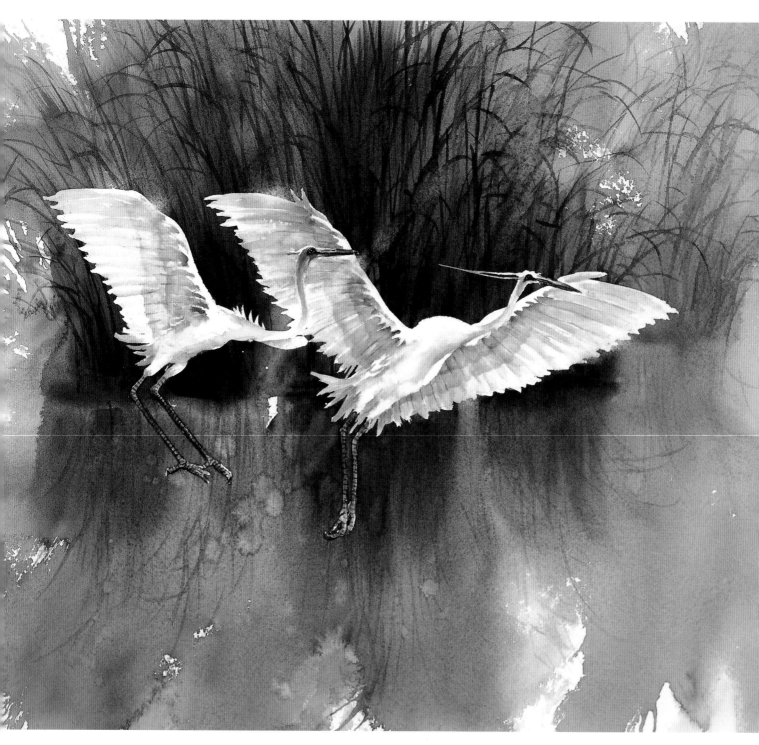

EGRETS *Watercolor 11" × 15" (28cm × 38cm) 140-lb. (300gsm) cold-pressed watercolor paper*

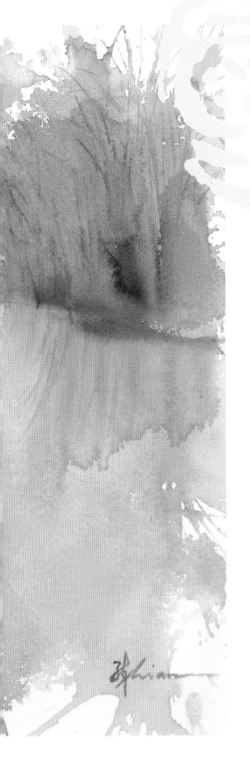

MATERIALS
& BASIC TECHNIQUES

1 Throughout this book you will be working with both Chinese and water-color materials. There are differences and similarities between the two. If we compare and contrast them, we will gain a better understanding of them.

Studying basic materials and techniques is like learning to use tools. Once you know how to use your tools, you can operate them safely and efficiently. When you learn how to use your painting materials and techniques, you can paint freely and have more fun.

COMPARE CHINESE AND WATERCOLOR PAPERS

There are two main types of Chinese painting paper, raw Shuan paper and mature Shuan paper.

Mature Shuan Paper

Mature Shuan paper is made by applying alum to both sides of the raw Shuan paper. It is soft, but not absorbent, making it great for painting with vibrant colors and many details, called detail style (see page 20).

Raw Shuan Paper

Raw Shuan paper is untreated, soft and very absorbent. It comes in either a single, highly absorbent layer, or a double, gently absorbent layer. Experienced artists choose single-layer raw Shuan paper for its magnificent blending effects; however, many amateur artists and those who want more control over blending like to use the double-layer raw Shuan paper because it is easier to control the colors. Double-layer raw Shuan paper resists tearing, it is also stronger and thicker than single-layer raw Shuan paper.

Both types of raw Shuan paper are used most often when you paint in spontaneous style (see page 20). In spontaneous style most artists usually start painting without sketching. However, some do use a soft pencil or charcoal to sketch the outline of the subject. If you choose to sketch, try to sketch lightly and brush off the excess charcoal once you finish so it won't damage the paper or show up strongly on your finished painting. You can also use a small brush loaded with light ink to sketch on raw Shuan paper. Keep in mind that you will trash most of your Chinese paintings as a beginner, especially if you paint in

Raw Shuan Paper
You can create watermarks on a single layer of raw Shuan paper by overlapping the strokes. This is more obvious when you paint with ink only (**1**). Colors blend on raw Shuan paper the way they can on no other paper. Create special effects by applying water on the edge of the strokes while they are wet. This is the *break ink* technique (**2**). Apply strong opaque colors such as light blue on top of wet, darker strokes to get strong effects—the dark is darker and the light is vivid (**3**). Colors on raw Shuan paper don't blend into one another like they do on cold-pressed watercolor paper (**4**).

Cold-Pressed Watercolor Paper
This photo shows the characteristics of Arches 140-lb. (300gsm) cold-pressed watercolor paper. I use this paper the most for my watercolor paintings because it allows the transparent colors to show their qualities (**1**). The colors blend into one another well, which is different from the raw Shuan paper (**2**). When you add thick pigment on a wet area, it blends out gracefully (**3**). Finally, similar to the *break ink* technique of raw Shuan paper, colors can be blended by wetting the edges of the stroke with water (**4**).

spontaneous style, because you can't correct your mistakes as easily on the raw Shuan paper as you can on watercolor paper. The best attitude to have is to treat each painting as an exercise rather than an attempt at a masterpiece. Have fun without feeling any pressure.

Watercolor Paper

The three types of watercolor paper are: cold-pressed, hot-pressed and rough. Hot-pressed paper is very smooth. Rough has a very rough texture, just as its name suggests. You will be using 140-lb. (300gsm) cold-pressed watercolor paper for the demonstrations in this book. It has slightly different textures on each side—one is smoother, for painting soft objects such as flowers and fish, while the other side is rougher, for painting landscapes. Its surface is also very durable and will not be damaged by scrubbing or lifting masking fluid. If you don't already have a preference for a particular paper, try several different brands since the attributes vary. Then you will be able to see which paper best suits your painting style.

Unlike using charcoal or light ink to sketch in Chinese painting, you can use medium pencil such as HB or B to sketch on watercolor paper. Hard pencil may scratch the surface of your paper. Soft pencil leaves heavy and dark lines that can mix with your paint and create dirty colors. After sketching, use an eraser to lighten the pencil lines so they do not disturb your colors.

Hot-Pressed Watercolor Paper
Colors don't blend as well on hot-pressed paper as they do on cold-pressed paper (top). Colors lift off easier on the hot-pressed paper than on the cold-pressed paper (bottom).

Mature Shuan Paper
Notice how mature Shuan paper does not absorb water or blend like the raw Shuan paper (top). You can layer many colors on the mature Shuan paper. These strokes of red are beautifully layered with each layer becoming more opaque (bottom).

BRUSHES

Chinese Brushes

Chinese brushes are made of animal hair. There are three types of brushes: soft, hard and mix. The soft brush is made of sheep and rabbit fur. The hard brush is made of wolf fur, ox and horsetail hair. The mix brush is made of both soft and hard hair and fur.

The tips of the Chinese brushes are longer than those of watercolor brushes. The long tip gives the Chinese brush the ability to hold more water and paint. This ability to absorb makes them ideal for painting on raw Shuan paper, which is highly absorbent and ideal for blending colors. The tip of the brush also allows for a variety of strokes. A pointed tip paints fine strokes, while splitting the tip creates special detail effects such as animal hair or fur.

Watercolor Brushes

Most watercolor brushes are made of sable or synthetic sable. Sable brushes are softer and able to hold more water than the synthetic sable brushes. I like to use synthetic brushes because they are very elastic and easy to handle. For example, when I paint dark values I create a thick mixture of paint using only a little water. The synthetic brushes are better for creating these mixtures. Synthetic brushes are also much cheaper than sable brushes.

Match Brush to Paper

The texture of the brush is more important in Chinese painting than it is in watercolor painting because of the differences in the absorbency of the paper. Watercolor paper does not absorb water and paint as well as the raw Shuan paper. Different textured watercolor brushes do not create as many different results on watercolor paper because of this. However, colors blend into each other more dramatically on watercolor paper.

I use synthetic sable brushes to paint watercolors because their hard texture is easier to handle. A large round synthetic sable brush can paint strokes on watercolor paper similar to how a Chinese hard fur brush can paint on Shuan paper. It is because the hair in a synthetic sable brush is like the fur in a Chinese hard fur brush. In Chinese painting, it is better to use the soft brushes to paint soft objects such as flowers and use hard brushes to paint rough objects such as rocks.

You may wonder if you can use Chinese brushes in watercolor painting, or vice versa. I don't recommend it because brushes are made according to the qualities and characteristics of their papers. Certain tools are used for specific jobs.

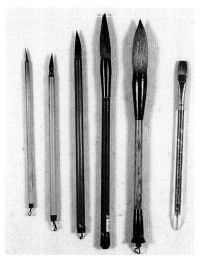

Chinese Brush Size
Unlike watercolor brushes that have numbered sizes, Chinese brushes come in sizes from extra-small to extra-large. This photo has four Chinese hard fur brushes ranging from extra-small to large, and one extra-large soft fur brush compared to a ¼-inch (6mm) flat watercolor brush. The rule of thumb is the larger the subject you're painting, the larger the brush you should use and vice versa.

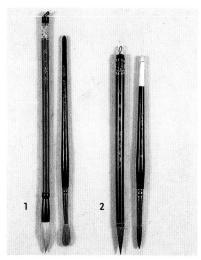

Compare Soft- and Hard-Textured Brushes
The first two brushes (**1**) have a soft texture: the sheep hair Chinese brush on the left and the sable watercolor brush on the right. The next two brushes (**2**) have a hard texture: the wolf fur Chinese brush on the left and the synthetic sable watercolor brush on the right.

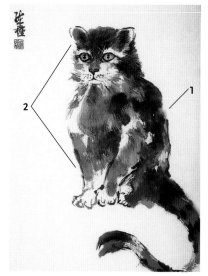

Using Different Brushes
This Chinese painting shows how you can use hard- and soft-textured brushes in one painting: soft brushes for the hair and hard brushes for the ears and legs.

Use soft brushes to paint the cat's hair (**1**) because you can easily create the soft strokes that *feel* like the animal's hair.

Use the hard brushes to paint strong and tough strokes, capturing the texture of the ear and the legs (**2**).

PAINT

Both Chinese paints and watercolors are water media. The paints gracefully blend on the paper, the brushes create magnificent strokes and the final results are transparent. However, there are differences between the Chinese paints and watercolors.

Chinese Paints

Contemporary Chinese paints come in tubes and are made of plants, minerals and glue. Their range of opacity lies between being as transparent as watercolors but not as opaque as gouache. I use nine pigments frequently: Blue (light blue), Burnt Sienna, Carmine (deep red), Cinnabar, Gamboge (yellow), Green (light green), Indigo, Vermilion and White. The glue in the Chinese colors is stronger than in watercolors, which makes the Chinese colors firmly bond on the Shuan paper after drying. As a result, the colors do not run together when you re-wet the paintings during the process of stretching the painting. This is important since Chinese paintings are stretched after the painting is complete rather than before, as with a watercolor painting (see page 120). This is also why you should not use watercolors interchangeably; they will run together if the Shuan paper is re-wetted.

Watercolors

Watercolors come in tubes, pans and cakes. In this book I'm using tube colors. Watercolors are transparent if you dilute them.

Chinese Paints
This box holds twelve tubes of Chinese painting colors. They are sold either in a set or individually. Chinese paints are not easy to find outside of China. Beginners can use Sumi colors (Japanese painting pigments). If you live near any Chinatowns, Chinese colors can be found in the bookstores and art galleries there. I list a few sources, including myself, for readers to easily get the Chinese painting materials on page 127.

Watercolors
Most of the time I use three primary colors to paint: Red, Yellow and Blue. Before 2003, I used Cadmium Red Deep, Cadmium Yellow Light and Ultramarine Blue often. Recently, I've been trying to avoid using the cadmium colors because they contain heavy metal that may cause poisoning. Therefore I've found red and yellow pigments that are close to the Cadmium Red Deep and Cadmium Yellow Light. I have tried Pyrol Red from Daniel Smith and Permanent Red Deep from Van Gogh. For yellow I've picked Azo Yellow from Van Gogh or from the Artists'. For blue, I started using Antwerp Blue more than the Ultramarine Blue because it has a stronger saturation and darker value. It is great for painting water and mixing dark colors.

ADDITIONAL CHINESE PAINTING MATERIALS

Besides Shuan paper, brushes and paints, there are additional materials for Chinese paintings. On most Chinese paintings, you see calligraphy and chops.

These two important elements are used for inscribing and sealing paintings, much like the artist's signature on a watercolor painting.

Creating Ink

Traditionally, Chinese artists make ink for painting and calligraphy by grinding an ink stick with clear water on an ink stone. The ink sticks for painting are made of rosin soot from burning oil, and are called old-smoke ink sticks. Ink stones are make of natural rock. When the artists are making ink, they calm themselves and focus their minds on forming their painting compositions. Today most of them use bottle ink instead because it is easier to carry and it saves them the time of grinding the ink stick. I use bottled ink for all the demos in this book. You may not be able to find the Chinese bottle ink in art stores but you can use the Sumi ink instead. Do not use India ink because when you dilute the ink with water it becomes a blue color.

1. Bottle ink
2. Ink stone with cover
3. Ink stick
4. Two paperweights

Varieties of Chops

This photo shows four chops and a wooden box containing oil-based rouge for stamping. Most chops are made of soapstone. They come in many shapes such as square, rectangular, circular and irregular. Every artist has his or her own name chop and some leisure chops, which are poem phrases and quotations. Both calligraphy and chops are considered important elements in Chinese paintings. Artists use them for inscription and to seal their paintings. Chops also balance painting compositions.

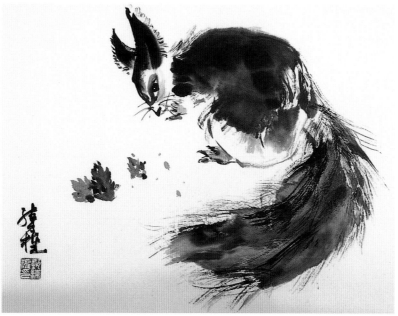

A Complete Painting

Here all the elements of a Chinese painting are tied together. The painting uses ink on raw Shuan paper. My signature and my chop on the lower left fill the empty space.

ADDITIONAL WATERCOLOR MATERIALS

I use masking fluid to preserve white areas on watercolor paper for paintings that are very detailed. It is a good tool for my *Color Pouring and Blending* technique (see page 70). You can also use Mold Builder (a liquid latex rubber compound found in most places where you can purchase art supplies). It is almost the same as art masking fluid, but it takes longer to dry. Use it for masking large areas. It is much less expensive than art masking fluid.

Masking fluid and Mold Builder are water-soluble materials. The Mold Builder is thick, so you need to dilute it before applying it to watercolor paper. Use about 1 part water to 3 parts Mold Builder. When a bottle of art masking fluid gets thick (this usually happens after you use more than half of the bottle), add a little water to thin it.

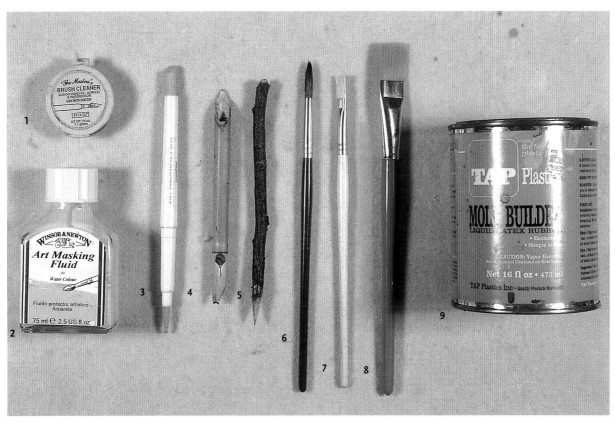

Applying Masking Fluid and Mold Builder
This photo shows you materials for applying masking fluid. Use the bamboo pen, twig and Incredible Nib for masking small details. Use the brushes for masking larger areas. Before using a brush to apply the masking fluid, wet it and dip it in the soap to protect it from damage by the masking fluid. Do not use masking fluid on Shuan paper for Chinese painting. It will not come off and it breaks the paper. To remove the masking you can use masking eraser, a small square shape similar to an pencil eraser. I use masking tape or packing tape instead. I use a small piece of tape about one to two inches (25mm to 51mm) long, hold it with my fingers with the adhesive side facing the masking, press the tape down on the masking and drag the masking up, removing it.

1. Soap
2. Masking fluid
3. Incredible Nib
4. Bamboo pen
5. Tree twig pen
6. Round brush
7. Flat brush
8. Flat brush
9. Mold Builder

CHINESE PAINTING STYLES

Spontaneous Style

Spontaneous-style painting is influenced by Chinese calligraphy and poetry. It is the dominant style since its full development during the Sun dynasty, about 1,000 years ago. This is the style that I use most for the demonstrations in this book. Spontaneous style interprets nature rather than copying it. Artists manipulate brushstrokes in an abbreviated manner. As a result, spontaneous-style paintings can be semiabstract and may use metaphors to depict the essence and spirit of objects without emphasis on details.

Detail Style

Detail style shows many more details than spontaneous style. This style is from ancient times. In fact, most of the paintings were painted in this style until the Sun Dynasty, when spontaneous style emerged. Detail style starts with outlining the objects with ink, then filling colors within the outlines. In paintings that depict a bird or an animal, the feathers and fur are clearly depicted; vivid and intense colors are also used. Artists handle their brushes carefully and slowly, and the brushstrokes are smaller and more uniform than in other styles of painting. You also use the less absorbent mature Shuan paper to allow all the details to show in this painting.

Detail style is the basic training for Chinese painting students. It teaches them to manipulate their brushes to acquire proper strokes, to observe and analyze details and to use colors.

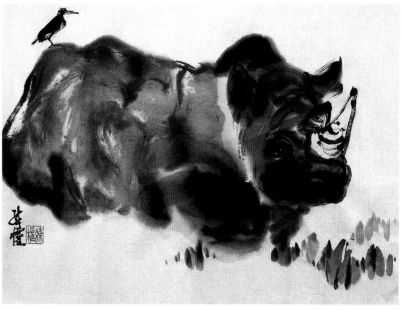

Rhinoceros 11" × 14" (28cm × 36cm) Chinese ink and colors on double-

Spontaneous-Style Painting

This spontaneous-style painting of a rhinoceros shows no small details. I varied the brushstrokes to suggest texture and movement. The head and body are defined by the brushstrokes rather than by an outline.

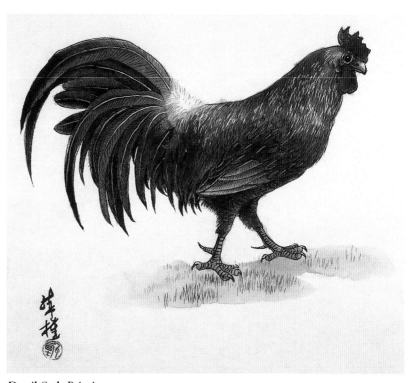

Rooster 10" × 14" (25cm × 36cm) Chinese ink and colors on mature Shuan paper

Detail-Style Painting

This detail-style painting shows intricate details such as the rooster's feathers and its legs and feet. The objects are formed with outlines and then painted with vibrant colors.

WATERCOLOR PAINTING STYLES

In the demonstrations I will tell you when to paint instead of using typical watercolor language. For example, I use words like *immediately* instead of *wet-in-wet*. I think people understand more clearly how to paint if they are told *when* they should apply another color. So if I use words like *while the surface is still wet, wait until it is about 50 percent dry, wait until the colors completely dry*, rather than tell them do it *wet-in-wet* or *wet-on-dry*. I use three methods for painting watercolors.

Traditional Painting
Using a brush to apply colors on the watercolor paper. I paint this way when I do outdoor sketches.

Half Color Pouring and Blending
Painting the main objects directly using traditional painting and then pouring colors to create the foreground and background. A typical example is the Cats demonstration on page 114.

Color Pouring and Blending
Start by masking out your main subjects and then begin pouring the colors to create the environment of the painting. Finally paint the details of the main objects. This technique is used in the Egrets demonstration on page 78 and the Elephants painting on this page (the demonstration is on page 70).

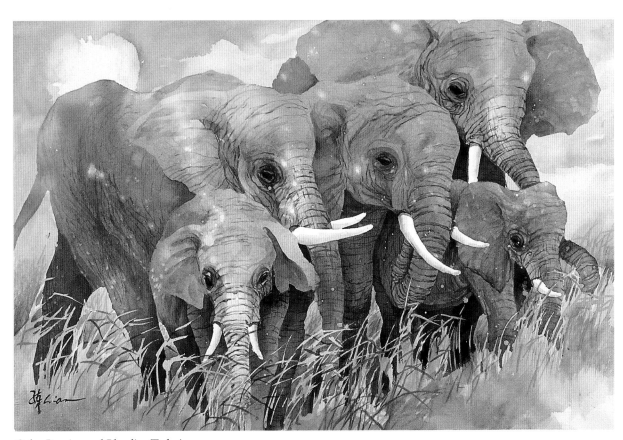

Elephants Watercolor 11" × 15" (28cm × 38cm) 140-lb. (300gsm) cold-pressed watercolor paper

Color Pouring and Blending Technique
I used the *Color Pouring and Blending* technique in this painting. Pouring the colors on the paper, instead of brushing them on in a wash, creates a beautiful effect for the foreground and background.

ARRANGING YOUR MATERIALS

Watercolor Painting Setup

I paint in watercolor on a flat surface in my studio. I use a Gator board or a plywood board to support the watercolor paper. The board is about 1 inch (25mm) larger than the paper so you should tape the paper onto it. Use either masking or packing tape to tape down four sides of the paper on the board. Lay out the materials similar to the Chinese painting setup.

Chinese Painting Setup

Create your Chinese paintings on a flat surface such as a table or counter. Use a felt or thick cotton fabric to cover the whole table or just the portion where the Shuan paper lies. The felt provides a flat surface and soft texture; it also absorbs the moisture from the Shuan paper. Use lighter-colored felt rather than darker-colored felt because you can see the dark colors through the Shuan paper and it will distract your eye. If you are right-handed, lay out the ink, colors, brushes, water container and paper towel on the right side of the Shuan paper to avoid dropping and splashing ink and colors on your painting. If you are left handed, lay out the materials on your left.

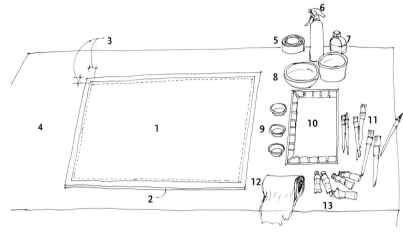

Watercolor Painting Setup

1. Watercolor paper
2. Gator board or plywood board
3. Tape
4. Table
5. Roll of tape
6. Water bottle
7. Masking fluid
8. Water container
9. Three small dishes
10. Palette
11. Brushes
12. Paper towels
13. Watercolors

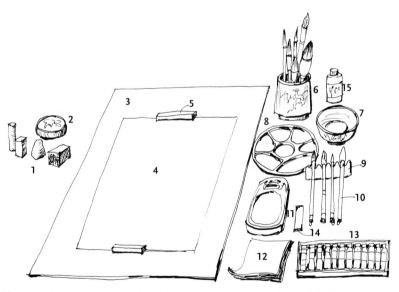

Chinese Painting Setup

1. Chop
2. Rouge
3. Felt
4. Shuan paper
5. Paperweight
6. Brush container
7. Water container
8. Palette
9. Brush holder
10. Brush
11. Ink stone
12. Paper towel
13. Paints
14. Ink stick
15. Bottle ink

CHINESE BRUSH TECHNIQUES

You'll need to learn a few Chinese brush techniques before you start painting. Start with holding the brush correctly and painting basic strokes. You will then learn to load multiple colors on one brush so you can use this technique to paint gorgeous subjects.

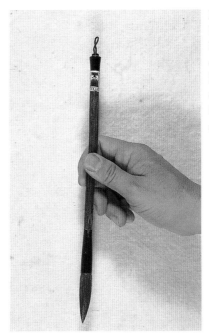

Holding the Chinese Brush
Use your index finger and thumb to hold the brush from middle to the top. Close your other three fingers together and put them between your palm and the brush. It may be difficult for you at first, but it gives you more freedom to paint than holding the brush like a pencil.

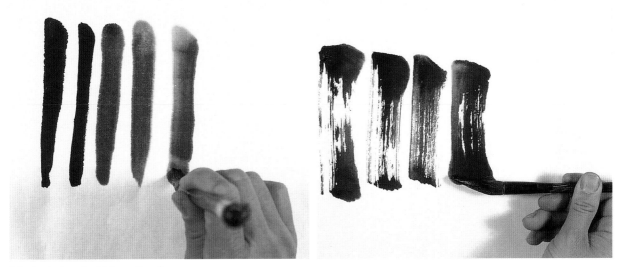

Manipulating the Chinese Brush
There are two ways to create strokes using a Chinese brush. The first (left) is called *center brush*, where you hold the brush perpendicular to the paper. It creates soft and full texture strokes. The second technique is called *side brush*. It involves holding the brush at an angle less than 90 degrees from the surface of the paper. You can use the side-brush technique to paint broken, rough strokes.

Loading Multiple Colors

In Chinese painting it is common to load several colors in a brush. This is especially true when you are painting in spontaneous style since you want to achieve the maximum effect with the least amount of strokes. This example shows you how to load a brush with Yellow, Vermilion, Carmine and Rouge. These colors range from yellow to orange, red and dark red.

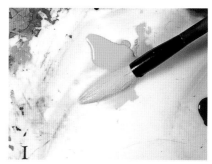

1

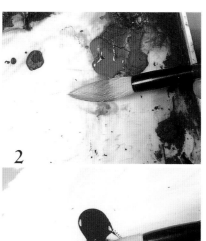

2

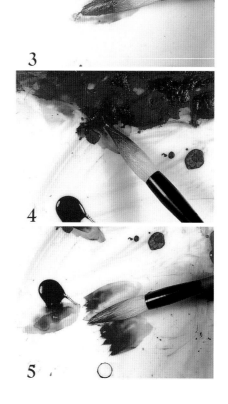

3

4

5

Loading the First Color

Soak the brush in water and let the water drip from the tip until you don't see any more drops. This means that you have the right amount of water in the brush to mix the colors. Let's start loading the Yellow (**1**). Hold your brush sideways and use the heel to pick up the pigment. Just touch the color lightly and roll the brush to allow all sides of the heel to absorb the color.

Load the Other Colors On the Brush

Next use the upper middle of the brush to pick up the Vermilion (**2**), the lower middle part to pick up the Carmine (**3**) and the tip to dip the Rouge (**4**); touch the colors lightly and roll the brush in the same way you loaded the Yellow. The colors may not mix well in the brush; dabbing it on the palette will allow them to blend smoothly into each other (**5**).

Painting With Multiple Colors

Use the brush you just loaded with multiple colors to practice the following examples.

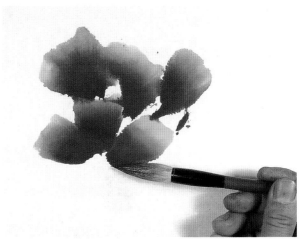

Paint a Flower

Hold the brush sideways and paint a few strokes. As you can see, you have painted part of a flower. Each stroke is one palette that has colors from yellow to orange, red and dark red.

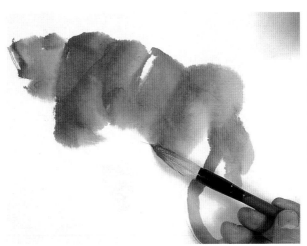

Sketch a Simple Tiger

Let's try sketching a tiger's body with the same loaded brush. Hold the brush sideways. Point the tip toward the left to paint the body in a few strokes.

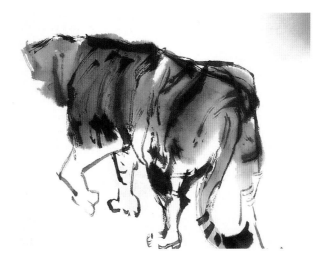

Detail the Tiger

Load another brush with dark ink to paint the stripes. Add a few strokes to define the legs. Notice how the tiger's shape is revealed. For more practice, try to paint a cat in the same way.

WATER-INK PAINTING

You have already learned that Chinese animal painting and Chinese characters evolved from a complicated form to one that is more simplified. In addition, the simplest style of Chinese animal paintings is using ink to paint in spontaneous style without any other colors. This is called *water-ink* painting. This technique captures the essence of the animals with minimal strokes and different tones of ink loaded like different colors onto a brush. I have tried not to apply more strokes than I need, nor fewer strokes than are necessary. In Chinese painting it is called, "One more stroke is too much yet one less stroke is not complete." In this demonstration I will paint two camels for you to see the power of such simplistic style. The images have the feeling of the camels, not the look of their real shapes.

✿ MATERIALS

PAPER
Single-layer raw Shuan paper

BRUSHES
Large soft fur • Small soft fur

CHINESE PAINTS
Ink

Loading Your Brush With Ink
Wet the brush with water. Use its tip and lower middle area to get the dark ink. The ink blends into the upper middle and heel of the brush gradually. As a result, the brush has dark ink at the tip, lighter ink toward the heel and mostly water at the end of the heel.

1 Paint the Head and Body
Fill a large soft fur brush with midtone ink from tip to heel. Then add darker ink to the tip. Hold the brush vertically and paint the head with one stroke from top to bottom (upper left). Immediately lift the brush and paint the neck in two strokes. When the ink in the brush is almost used up, paint the hump by holding the brush sideways with the tip facing upper left. Load more midtone ink onto the brush to paint the chest. Each stroke should touch the one before it to create beautiful watermarks between them.

2 Continue Painting the Body
Load the large brush with more midtone ink. Paint the other hump and the back in two strokes. Then paint one stroke for the stomach. Use a small brush to paint the front leg with darker ink while the body is still wet.

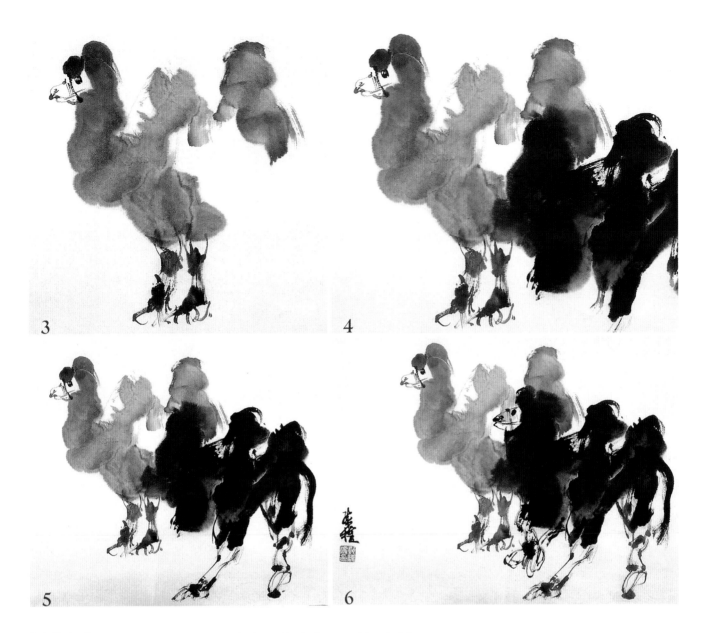

3 Add the Face

Continue using the small brush to paint the other leg. Use several strokes with the same brush to paint the face and the eye with dark ink. Add one stroke of darker ink on top of the forehead to depict the red fabric balls people put on these camels.

4 Paint the Second Camel

When the first camel is still wet, paint the second camel in front of it. Load a large brush up to the heel with a small amount of midtone ink. Then soak the middle and tip with dark ink and add very dark ink on the tip. Now the brush contains a variety of ink tones: from very dark at the tip, to medium at the heel. This allows you to achieve a multitone result in just one stroke. Now paint the second camel in several brushstrokes from head, neck and hump down to the body just like the first camel. Let the ink on the head and neck areas blend a little into the first camel to paint the nose and tongue.

5 Paint the Legs and Tail

Use the small brush to paint the rear legs and the tail. First outline the legs, then add the joints.

6 Add Final Details

Use the small brush to paint the other two legs and the face. I completed this painting using minimum strokes. Soft and broad strokes depict the muscles of the bodies while the strong and broken strokes catch the texture of the bones and the structures of the heads and legs. To finish the painting, I signed the lower left corner and stamped the chop under it.

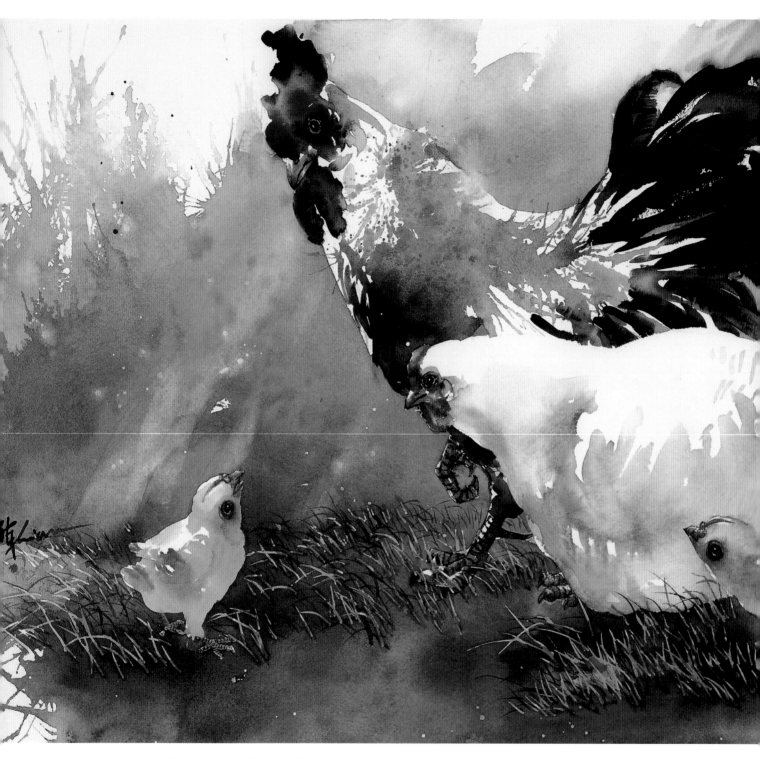

Rooster With Chickens *Watercolor 11″ × 15″ (28cm × 38cm) 140-lb. (300gsm) cold-pressed watercolor paper*

COMPOSITION

2 Composition is the soul of a painting. When your painting has a good composition, you are already halfway toward creating a wonderful piece of art. What is a good composition? I believe a good composition is a graceful and comfortable arrangement of objects in a painting, where the viewer's eye can travel with interest and ease. For example, if you were photographing three of your cats, you would most likely capture the moment they are in dramatic positions: two playing and one approaching to join the action, one standing and two sitting, or three chasing a toy. This invites the viewers to *act* with your cats rather than just displaying your cats to them. In this chapter you will learn the fundamentals of creating interesting compositions for your paintings.

FIND THE RIGHT COMPOSITION WITH TRACING PAPER

When I was studying and practicing architecture, I learned to use tracing paper for sketching designs. Once I finish a rough design scheme, I lay another piece of tracing paper on top of it to do another sketch based on the first one, which I can see clearly through the tracing paper. After working on several layers of tracing, the mature design is revealed.

You can use two methods based on this design process to work out the compositions for your paintings.

Method 1

In this method you start with two separate subjects and create a composition by moving them around in different positions on the paper. Sketch two frogs on two separate small pieces of tracing paper. Make one frog sitting and the other swimming. Then get an 11" × 15" (28cm × 38cm) sheet of watercolor paper and move the two frogs around to test different compositions.

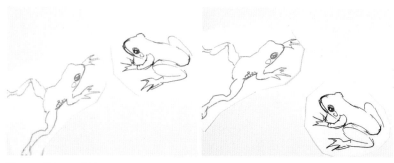

Form a Diagonal Force
Place the sitting frog in the upper right corner and the swimming frog at lower left. The frogs form a diagonal force from the upper right to lower left. Then move the sitting frog to the lower right and the swimming frog to the upper left. Now you have another diagonal arrangement of the objects. The diagonal arrangement reinforces the anticipated action of the frogs: they could jump at any second.

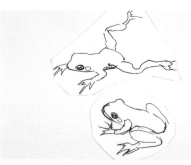

Use Both Sides of the Tracing Paper
Flip the swimming frog and move it to the upper middle right. The sketch is visible on both sides of the tracing paper—an advantage of using it. This composition is one of the many choices. It is a good one because the two frogs are curiously looking at something. The viewer's eye is enticed by the frogs and also becomes curious.

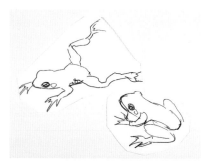

Notice Composition Flaws
Leave the sitting frog in his position. Move the swimming frog further left. This composition forms a diagonal force again, but the upper right area needs something such as water plants to fill the empty space.

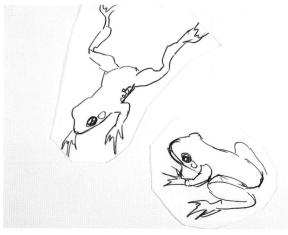

Make the Composition Dramatic
Rotate the swimming frog in a larger angle so it looks like he is jumping down. Now one of the frogs is sitting while the other is jumping. This strong contrast in action creates a dramatic effect.

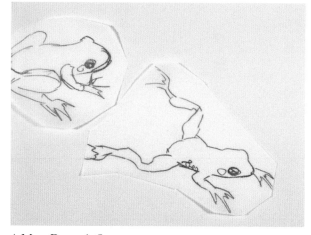

A More Dynamic Scene
Flip both frogs and place them facing the lower right. Notice how this composition looks much different from the previous arrangements. It is a different arrangement of the frogs, not necessarily better or worse than other arrangements. However, this is a faster and more active scene.

Method 2

First sketch a composition on tracing paper, the same size as the watercolor paper, 11" × 14" (28cm × 36cm). Then cut it apart and move the elements around to form new compositions.

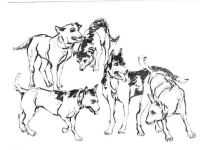

Identify Composition Problems

Here is a quick study of a dog painting. Notice the compositional problems: the focal point is weak, there is a lack of communication between the three dogs in the front and the two in the back and the dogs appear crowded into this small space, which makes the composition somewhat out of proportion.

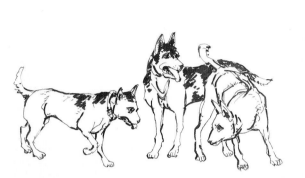

Composition Solution 1

Cut out the two dogs on top with a pair of scissors. Move the remaining three dogs about 1½ inches (4cm) higher. The result is a new composition with three dogs that has a stronger focal point and better proportions.

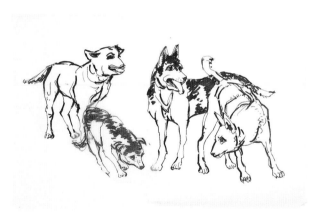

Composition Solution 2

Here they are interacting with one another indirectly. To see this you can draw a line connecting the heads of the four dogs starting from the one at the upper left to the one at the upper right, then to the one at the right front and to the one at the left front.

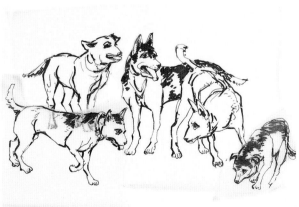

Composition Solution 3

This five-dog composition is better than the initial example because the focal point is stronger. There is also a larger space in the lower front for the dogs to act. The focal point is in the middle triangle area formed by the heads of the three dogs. The other two dogs are approaching to the focal point.

PUT OBJECTS IN A COMFORTABLE SPACE

I call this technique the *living room design* composition method to help understand the concept of space. For example, say you are designing a living room for a four-member family. The size is about 18' × 25' (6m × 8m). This makes it large enough to accommodate regular furniture while everyone in the family can gather together comfortably. If the room size is smaller, 12' × 15' (4m × 5m), it will be too small. On the other hand, if its size is 30' × 40' (9m × 12m), it will be too big.

Objects should fit as comfortably onto the size of your paper as if they were furniture fitting into your living room. Analyze the following three scenarios to understand this concept.

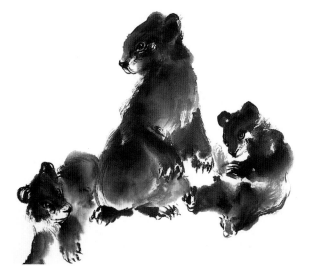

Too Cramped
In this sketch the bears seem too big for the paper. They can't act freely in such a small space. It would be like three humans playing in a 5' × 6' (1½m × 2m) room—there isn't enough space to move around. This composition does not look comfortable at all.

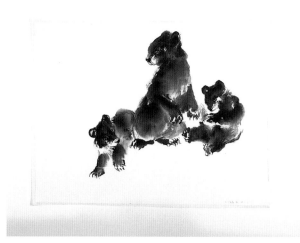

Too Spacious
If you place the sketch on a larger piece of paper, you can see how the bears are in a grand space, but it is too big for them. This is similar to a 30' × 40' (9m × 12m) living room for a three-member family. The painting is not visually comfortable because the bears are too small to create a strong focal point.

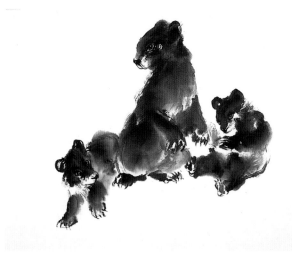

Just Right
The bears fit better in this space: it's not too small or too big. The "living room" is now just the right size.

ADD AND SUBTRACT COMPOSITION ELEMENTS

How many objects should you put in a painting? My answer is whatever number of objects comfortably fits onto the paper. Practice adding and subtracting objects to create different compositions.

Let's sketch five cats to learn how to add or subtract objects to form great compositions. First, sketch five cats individually on five pieces of tracing paper, each about 3" × 3" (8cm × 8cm). Then start arranging the cats on an 8" × 11" (20cm × 28cm) piece of paper.

After you get a working composition, tape the cats together. Use a light box or graphite paper to trace the cats onto watercolor paper.

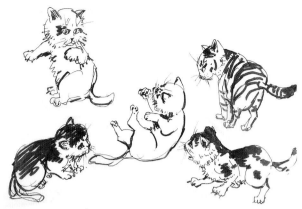

Composition 1
This is the first composition where you have all five cats. Notice there are too many of them jammed into this tiny space.

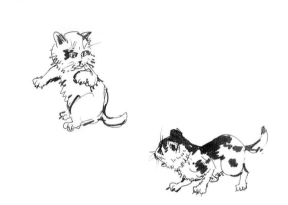

Composition 2
Take out three cats. This composition leaves too much space on the paper.

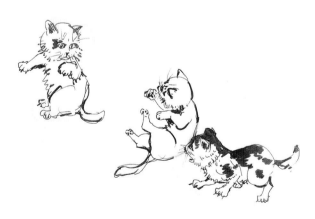

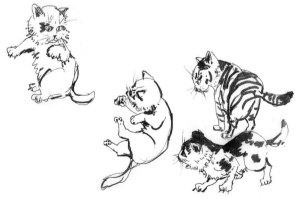

Composition 3
Take two cats away form the first composition. Move the one in the middle slightly to the right, overlapping it a little with the cat at the lower right. This is a much better composition because three cats occupy more space on the paper, putting the cats and the size of the paper in better proportion. The balance between the one in the upper left and two in the lower right, is less *perfect* than the two-cat composition. It is an asymmetrical composition that suggests more action.

Find the Best Solution
Try to work out a four-cat composition based on the first composition. This fits on the paper very well—and the relationship of the cats to each other is much better than the five-cat composition. Adding a fourth cat on the upper right also fills the empty space. It is not important whether or not you have an odd or even number. It is just important that the animals fit comfortably on the painting.

MAKE SUBJECTS COMMUNICATE

As humans, lack of communication between one another can make our lives miserable. Normally we greet our neighbors, talk to our friends and hug our loved ones. Animals in a painting should also communicate with one another or the they will not seem comfortable together in the scene.

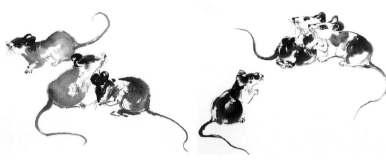

Bad Communication
These three mice do not communicate with one another. It seems there is no reason to put them in the same picture. I always joke that this is similar to how teenagers interact with their parents.

Good Communication
The actions of the mice help them relate to each other: The two at the upper right are looking at the upper left curiously, while the one at the bottom left pays attention to them. The whole scene tells a little story, which the viewer can imagine.

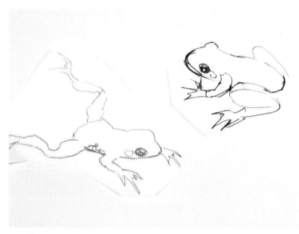

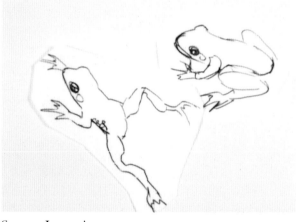

Weak Interaction
This example shows the lack of communication between the two frogs. They face and act toward different directions. I jokingly refer to this as the *seven-year itch*. In this case it would be better to paint only one frog.

Stronger Interaction
This arrangement is better than the first one. Two frogs are facing and acting toward the same direction. You can imagine that they are socializing together.

Strongest Interaction
This composition shows a much stronger relationship between the two frogs. They act like very close friends or a couple. Viewing this painting is pleasant, and the viewer can imagine a story of friendship or love.

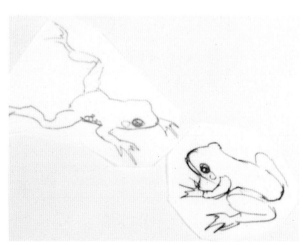

LEAVE SPACE FOR MOVEMENT

If you are painting a subject in motion, you must construct the composition with enough extra space to allow the subject to move or interact with other elements in the composition. This space is both visual and imaginary.

Imaginary space is the area between the acting animals and their final destination. For instance, if a dog is running toward you from about 10 feet (3m) away, the space between the dog and you is imaginary space. If that scene were the composition of a painting, the 10-foot (3m) space would appear empty, but the viewers can imagine what would happen there.

Leave Enough Space for Movement
The lion is slowly moving to the right toward his target. I left more empty space at the right side of the paper for his action. It looks logical and comfortable on the painting.

Not Enough Space for Action
Two monkeys are looking toward the right and one at the viewer. They would each most likely act in those directions. I should have left more space at the bottom and the right side.

Create More Space for Interaction
This sketch provides plenty of space for the monkeys to interact with the butterfly.

IDENTIFYING ACTION SHAPES

Animals and objects on a painting form a shape like a shadow cast on the ground. The more dramatically curved the shapes, the more action they suggest. Static shapes, like squares and perfect triangles, do not suggest very much action.

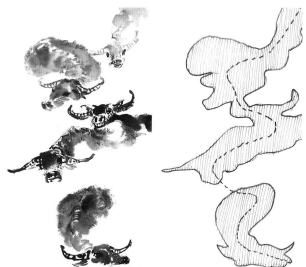

S-Curves Show Action

If you ignore the detail but only view the cows as one collective shape, you see the shape of this painting like a multi S-curve. This curve suggests the movement of the animal: swimming across a creek.

Squares Show Less Action

The two cows are sitting down, having a nice talk—mooing at each other. The square shape suggests less action.

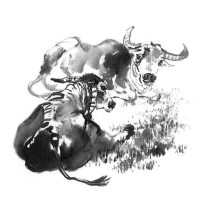

More Curves Show More Action

The three horses form a curvy shape that emphasizes their fast running motion.

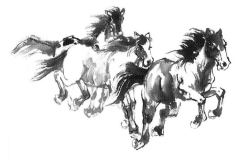

A Relaxed Moment

The overall shape of these horses is more square or static, which helps show the relaxed moment of the horses.

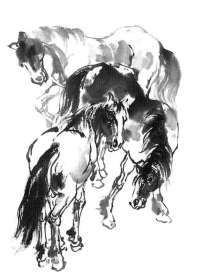

IMPROVE YOUR COMPOSITIONS WITH DYNAMIC OUTLINES

The outline defines the edges of the shapes. The edges should vary to create an interesting silhouette. If varying the edges isn't enough to liven up your painting, try breaking up the outline of the main subject with smaller additional elements. These examples will help you increase interest in your paintings by revising the outline.

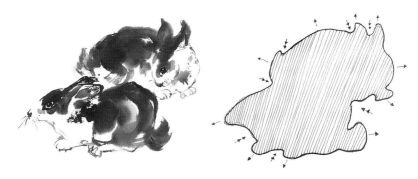

A So-So Painting
This painting of two rabbits is interesting, but could it be revised to have a better overall shape? One way to tell is to look at the outline or silhouette of the shape. The edges curve in and out to form an interesting pattern, but we can further develop them to make the rabbits more dynamic and attractive.

A Dynamic Improvement
I revised the first painting of the rabbits by lifting their ears and further extending their legs. Now the outlines bounce in and out, up and down, more dramatically. The rabbits appear much livelier and the painting looks more exciting.

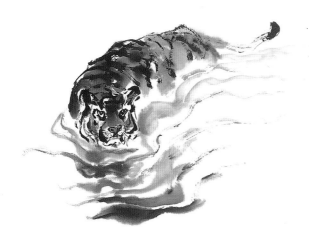

A Boring Outline
The back and tail of the tiger form a long, predictable outline. You can modify the outline for more curves by raising the tail or dropping it more. However, such modification does not address the line of the back.

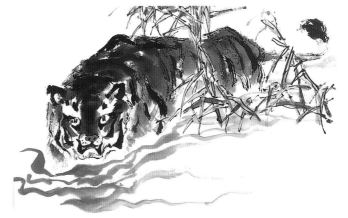

Break It Up
I added some waterweeds to break up the outline twice. This time the whole composition works better. You should avoid breaking up the outline at the middle of the composition. Otherwise it looks too balanced.

LEAVE THE RIGHT AMOUNT OF WHITE

It is hard to leave white (unpainted areas) in our paintings because we observe that almost everything in nature has a color. However, the white in Chinese and watercolor paintings is very important because it suggests highlighting and shapes and inspires imagination and curiosity. It can also be an intriguing part of the composition. Leaving the white on a painting for the viewer is the same as telling a story without giving away the ending. This allows the viewer to use his or her own imagination when seeing the painting.

Artists often have more difficulty dealing with unpainted areas than painted areas.

Since we do not see white on objects, how do we decide where to leave it? There is no absolute rule for the amount of white you should leave on a painting. I usually leave it on the parts receiving light: edges, outlines and joints, as well as the area of the painting where the animal is approaching.

No White
This painting has no white. I call it a *breathless* composition—there is no space for you to engage your imagination, so there is no interaction between you and the picture.

Some White
Unlike the previous painting, this work has some white on both the dog and the background. It loosens up the painting and suggests texture on the dog—providing a little curiosity for the viewer.

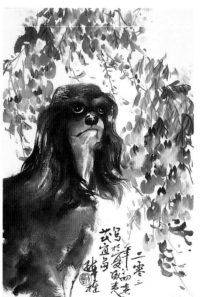

Enough White
This painting leaves the appropriate amount of white, giving a better result. The whites on the dog suggest the highlights, texture of hair and body outline. Meanwhile, the white of the background suggests the depth of the painting and invites you to enter the scene.

ENHANCE A COMPOSITION WITH COLOR AND VALUE CONTRAST

A successful composition not only has a nice arrangement of objects, but it also has a strong contrast in value (dark against light or vice versa) and color. There should be one dominant color in a painting, one which tends to pull the whole picture together. Painting small areas around the dominant color with its complements makes the color more dramatic. For instance, adding a little blue or green to a painting that is primarily red can make the red more vivid to the viewer's eye.

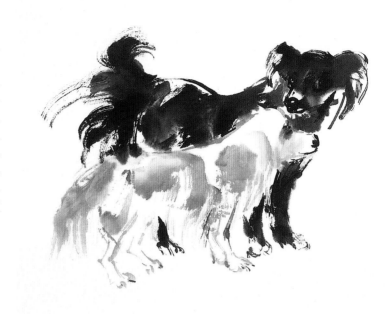

Use Values to Enhance Your Subject
The dark ink of the rear dog visually pushes the focus to the front dog drawn in lighter ink, while also outlining the front dog.

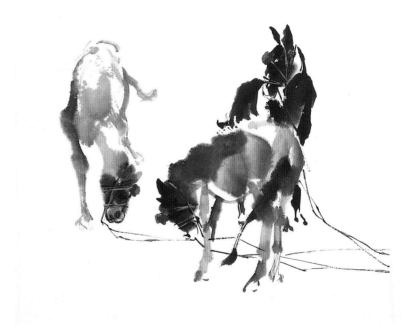

Create Visual Impact With Warm and Cool Colors
This painting has visual impact because the cool color donkeys are set against the warm color red fabric flowers and the orange ropes.

ESTABLISH A STRONG FOCAL POINT

The most important aspect of composition is the focal point, or center of interest. When I critique my students' compositions, the first question I ask is, "What is your focal point or center of interest?" This is similar to asking them, "What is your goal in life?" If you have clear and reasonable answers for these questions, your painting and life will work out better. To get a better idea of how to establish a focal point, let's analyze the following sketches.

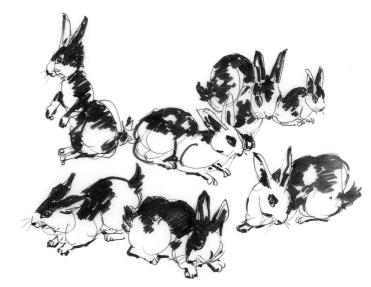

No Focal Point
There is no focal point here. The four rabbits on the right are interested in something toward the right while the other three are looking in the opposite direction. They are almost equal in color, size and motion. None of their actions is directing the viewer's eye toward anything in particular. This sketch needs to be revised to contain a focal point.

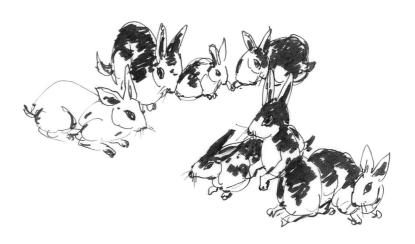

Clear Focal Point
Now all of the rabbits interact in some way, directing the viewer's eye to the focal point. I also enforced the focal point by making the rabbits closest to it bigger and darker, and the ones farther away smaller and lighter.

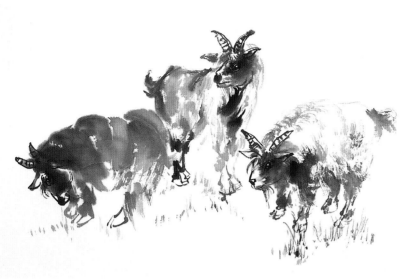

Weak Focal Point

I looks like any one of the three sheep could be a focal point. The center sheep slightly dominates because it is in the center of the three and sits higher than the other two.

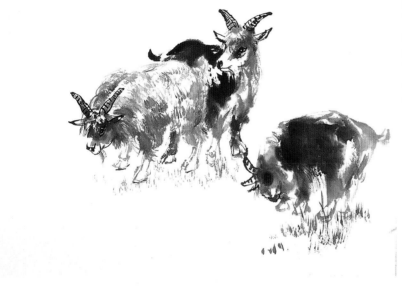

Stronger Focal Point

This painting has a stronger center of interest than the previous one because two of the sheep overlap each other more in the center. The two sheep are forming a larger mass at a central place of the painting, drawing the viewer's eye toward them.

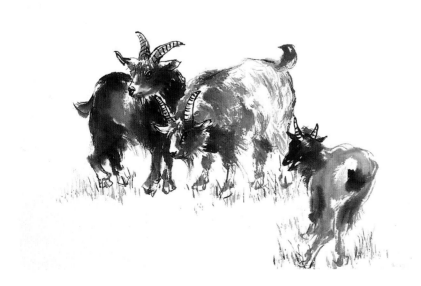

Strongest Focal Point

This composition has a very strong focal point—the heads of the two sheep are facing the viewer. The color and the mass of the two sheep dominate the painting. Also, the sheep in lower right is looking at them, directing viewer's eye toward the center.

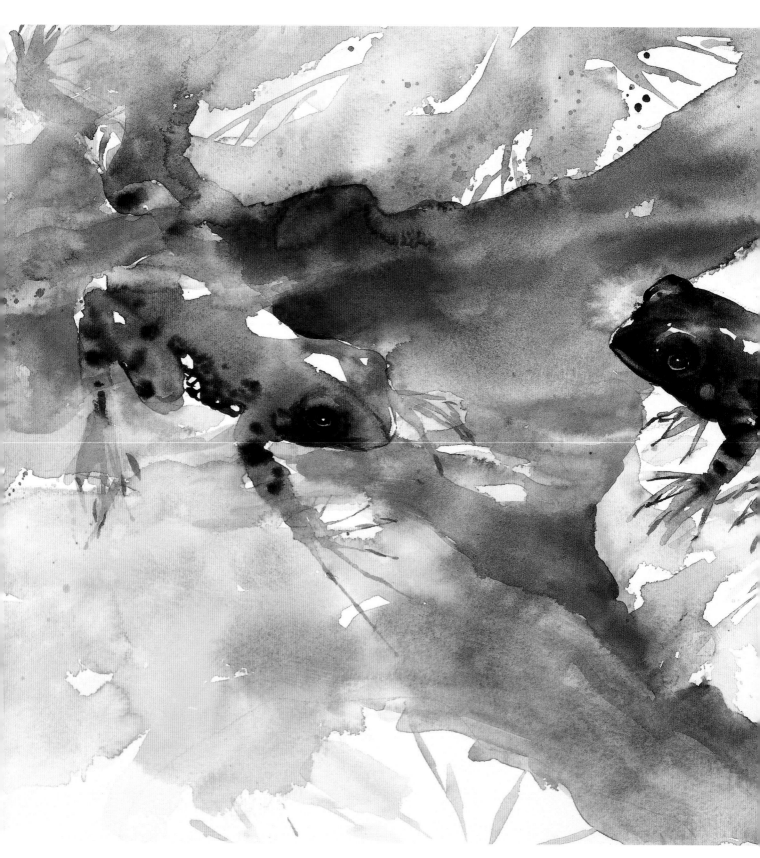

FROGS *Watercolor* *11″ × 15″ (28cm × 38cm)* *140-lb. (300gsm) cold-pressed watercolor paper*

ANIMAL
BODY BASICS
3

Before you jump into painting animals, you first need to practice painting different parts of their anatomies. This chapter teaches you how to paint animal heads, hair, eyes, hands and feet using Chinese and watercolor techniques. You should use Chinese materials for Chinese paintings and vice versa.

One of the major differences between Chinese painting and watercolor is how the artist defines objects. In Chinese painting artists use strokes to outline the objects, but in watercolor, artists use mass or surfaces to render the objects three-dimensionally. This makes light and shadow not as essential in Chinese painting as they are in watercolor.

ANIMAL HAIR

This demonstration teaches you how to paint animal hair in spontaneous style on double layer raw Shuan paper. You usually use a hard fur brush to create rough-textured hair on animals such as horses and cows. Use a soft fur brush to paint soft-textured hair for animals such as cats and dogs.

❋ MATERIALS

PAPER
Double-layer raw Shuan paper

RUSHES
Large soft fur • Small hard fur

CHINESE PAINTS
Carmine • Ink • Vermilion • White • Yellow

1 Load Colors Onto the Brush

Wet the large brush with clear water and load it with Yellow from middle to heel. Load Vermilion on its tip up to the middle. Lay the brush sideways on the palette to mix the Yellow and Vermilion a little so they blend into each other in the middle of the brush. Load a little Carmine on the tip. Now the brush has a range of three colors: from red to orange to yellow, and they blend gracefully. Hold the brush horizontal to the paper and pull down to create your first stroke.

2 Add Texture

Without washing the brush, load a midtone color on its tip. Split the tip with your fingers. Hold the brush vertically, or slant it slightly on the paper. While the first stroke is still wet, paint several strokes to create the texture of hair. Always paint in the direction the hair grows.

3 Paint the Dark Hair

Don't wash the brush. Dip the tip into dark ink. Split the tip as you did in step 2. Paint the dark hair on the end of the midtone hair; then paint more hair in the upper left by washing your brush and repeating the first two steps.

4 Highlight the Hair

Wet the small brush with a little water. Load on Yellow from middle to tip. Mix White into the brush. Split its tip to paint the bright Yellow highlights.

TIGER HAIR

Unlike Chinese painting, I do not use white paint in watercolor. Instead I leave unpainted areas to suggest the white hair.

�ड़ MATERIALS

PAPER
140-lb. (300gsm) cold-pressed watercolor paper

BRUSHES
1-inch (25mm) flat • Fan

WATERCOLORS
Cadmium Red Deep • Cadmium Yellow Light • Ultramarine Blue

1

2

3

4

1 Create the Wash

Wet the paper with a 1-inch (25mm) flat. Leave some small areas dry to create the illusion of highlights. Load the brush with Cadmium Yellow Light. Add a little Cadmium Red Deep to the tip to create an orange color on the tip changing to yellow at the heel. Hold the brush sideways to paint several strokes from left to right. This will create the tiger's body.

2 Grade the Color

Immediately pick up more Cadmium Red Deep with the brush tip. Apply it to the sides of the previous strokes. Blend the pigments into one another for a beautiful gradation of color.

3 Create the Stripes

Use the same brush to pick up Ultramarine Blue. Mix it with a touch of Cadmium Red Deep, making a dark purple. Then add more Ultramarine Blue to make the purple nearly black. When the color is dry it will appear darker. Paint the stripes while the surface is still wet.

4 Detail Hair

Use the fan brush to define the hair. Paint it with darker hues than the skin colors. For example, create a brown mixture on your palette of Ultramarine Blue, Cadmium Red Deep and Cadmium Yellow Light to paint the hair on the orange area of the skin. Remember to move your brush in the direction the hair grows.

CAT EYES

Eyes are the most important tool in capturing an animal's spirit. Animal eyes come in all shapes and sizes. Most animal pupils are black with a touch of white where the highlight falls. The upper part of the eyes is shadowed, making it darker, because of the indentation of the eye socket.

This demonstration teaches you how to paint two pairs of cat eyes in spontaneous style. Although each pair of eyes is a different color, you will use the same method in both of them.

❦ MATERIALS

PAPER
Single-layer raw Shuan paper

BRUSHES
Small hard fur

PAINTS
Ink • Light Blue • Vermilion • White • Yellow

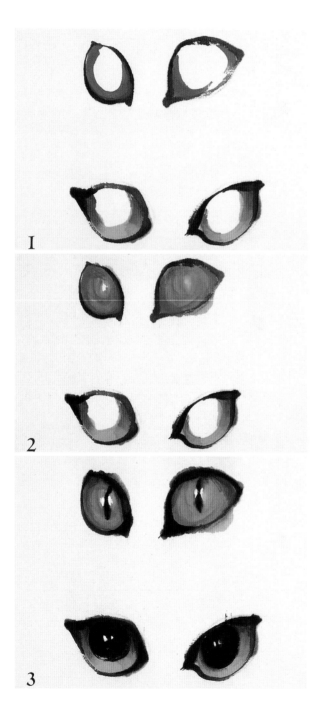

1 Shape the Eyes

Paint the outline of each eye using dark ink and the small brush. Use two strokes for each eye: one for the top and the other on the bottom. Paint the strokes in varied width to create the illusion of shadow and texture. For example, the broader strokes at the top suggest the shaded part of the eyes. Let dry. Paint in the top pair of eyes with Light Blue and the bottom pair with Yellow. When the colors are almost dry, add Yellow onto the top eyes and Vermilion to the bottom pair.

2 Paint the Top Pair of Eyes

Let's say this pair of eyes is in sunlight, which makes the pupils small vertical black lines. Paint more of the eyeballs and leave little highlights at the upper middle. Sometimes the colors blend so you lose the highlight, which happened here with the right eye. In this case, use White to add the highlight.

3 Create Pupils and Final Highlights

When the eyeballs are almost dry, use the small brush to paint the pupils with dark ink. Leave a little white on each pupil as its highlight. Make sure the ink isn't too wet, or it could blend too much. Notice how the ink in the lower-right pupil bleeds slightly into the yellow-orange eyeball, creating the radiant effect. This gives the illusion of pupil texture. The pupil highlights almost disappear because the ink blends too much. Add a thick layer of White with the small brush to enhance the highlights. Add one stroke with dark ink on each upper eyelid to depict the shadows.

TIGER EYES

Let's learn how to paint a tiger eye in watercolor. First, use a photo to try to create the basic shape of a tiger's head. Follow the next steps to create an interesting eye. I try to let the colors blend and mix on the paper rather than on the palette. Watercolors have great blending quality. If you blend them on the paper they are more graceful and clean. Sometimes artists say, "watercolor paints itself."

✳ MATERIALS

PAPER
140-lb. (300gsm) cold-pressed
watercolor paper

BRUSHES
1-inch (25mm) flat • No. 10 round

PAINTS
Cadmium Red Deep • Cadmium
Yellow Light • Ultramarine Blue

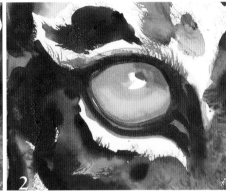

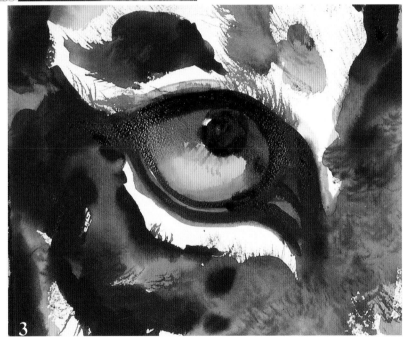

1 Outline the Eye
Wet the no. 10 round with a little water. Heavily load it with Ultramarine Blue. Then mix it with Cadmium Red Deep to get a dark value. Paint the outline of the eye.

2 Create a Round Shape With Value
Paint the eyeball with Cadmium Yellow Light using the 1-inch (25mm) flat. Leave the upper-middle part of the eye white for the highlight. Load the same brush with Cadmium Red Deep and paint the bottom of the eyeball. Blend the red into the yellow so the bottom of the eyeball has a darker value than the middle area. This gives the impression of a round shape. Load the same brush with Ultramarine Blue to paint the shadow across the top of the eyeball.

3 Add Final Details and Highlights
When the colors are almost dry, use the no. 10 round to paint the pupil. Use a dark mixture of Ultramarine Blue and Cadmium Red Deep. Leave a small highlight on the upper left. Deepen the red at the bottom of the eye using the flat brush. Paint the top shadow darker by adding one stroke of the Ultramarine Blue and Cadmium Red Deep mixture. Since the eyeball is an intense yellow, you shouldn't paint more than two strokes for the shadow or the color could become dirty.

MONKEY HANDS

The anatomy of monkey hands resembles that of human beings. Let's paint a pair of monkey hands in spontaneous style to learn the necessary techniques.

✣ MATERIALS

PAPER
Single-layer raw Shuan paper

BRUSHES
Large and small hard fur

CHINESE PAINTS
Carmine • Ink • Vermilion • Yellow

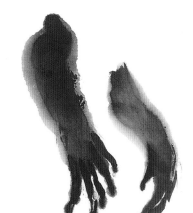

1

2

3

4

1 Create a Basic Shape

Dip the large hard fur brush in water. Load multiple colors in your brush, starting with Yellow from the tip to the upper middle, Vermilion from the tip to the middle, Carmine from the tip to just below the middle and dark ink at the tip. The colors in your brush from the tip to heel look like this: dark red, red, lighter red, orange, yellow, light yellow, water. Hold your brush slightly sideways to paint each hand with one large stroke from shoulder to palm. Next, add a midtone ink to the tip, using the same brush without washing out the other colors. Split the tip and paint the hair at the palm from top to bottom.

2 Create the Fingers

You don't need to wash the brush, just pick up more Carmine with it. Let the Carmine soak into the brush and combine with the other colors, add ink to the tip. Hold the brush perpendicular to the paper to paint each finger with one or two strokes. Press your brush harder on the paper at the joints to get the wider portion.

3 Paint the Hair

Paint the hair with the large hard fur brush while the colors in the brush are wet. Lay the brush on a paper towel to get rid of most of the water. Then load it from tip to middle with dark ink. Try to get enough ink to keep the tip split. Since you still have some other colors left on the brush, this should be a dark reddish-brown color. Paint the hair according to the direction it grows—from top to bottom and from inside out.

4 Paint the Fingertips

While the colors are still wet, use the small brush to paint the fingertips with dark ink.

FROG LEGS AND FEET

Here you will learn how to paint frog "hands" (or their two front webbed feet, depending on how you look at it) in a fun way with watercolor. While you concentrate on the legs and feet you will also learn how to paint close-up details of the frog's head and body.

⌘ MATERIALS

PAPER
140-lb. (300gsm) cold-pressed watercolor paper

BRUSHES
1-inch (25mm) flat • No. 4 round

WATERCOLORS
Cadmium Red Deep • Cadmium Yellow Light • Ultramarine Blue

OTHER
No. 2 pencil

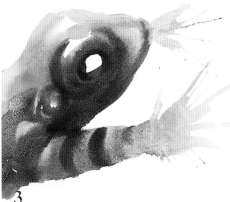
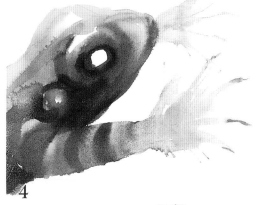

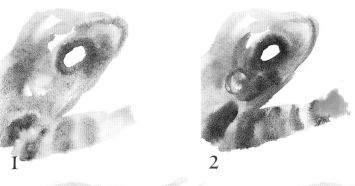

1 Create a Basic Frog Shape
Lightly sketch the head, body and leg of the frog. Wet these areas with the 1-inch (25mm) flat. Leave some dry areas on top of the eyelids and for the eye. Apply a thin layer of Cadmium Yellow Light on the wet area. Immediately add some Ultramarine Blue on most of the yellow areas, blending the colors into each other.

2 Paint the Wrist
With a clean 1-inch (25mm) flat apply more Cadmium Yellow Light and a touch of Cadmium Red Deep at the ankle area. Both colors should combine on the paper to make an orange color.

3 Create the Foot Shapes
Add a couple of drops of clear water on the orange area. Use your mouth to blow the orange to the right to get the shape and impression of the foot. Paint the other foot in the same way. Sometimes you may not

get the correct number of toes. Use the no. 4 round to drag the orange color to add more toes or use the 1-inch (25mm) flat to wash out the excess ones with water.

4 Paint the Webbing and Toes
When the orange is about halfway dry, paint the webbing between the toes using Ultramarine Blue and the 1-inch (25mm) flat. Use the no. 4 round to extend the fingers with

a mixture of Ultramarine Blue and Cadmium Red Deep.

5 Add Final Details
Paint the details of the palms with Cadmium Red Deep and a thin layer of Ultramarine Blue using a no. 4 round. Use a thicker concentration of Ultramarine Blue and Cadmium Red Deep to paint the tips of the toes.

ROOSTER LEGS

In this demonstration you will paint two rooster legs, each with a different method, but achieving a similar result. The demo for the left leg illustrates *No-Bone* style. In this method you start painting with color and ink together. The demo for the right leg illustrates the *Bone* style. This method starts by outlining with ink.

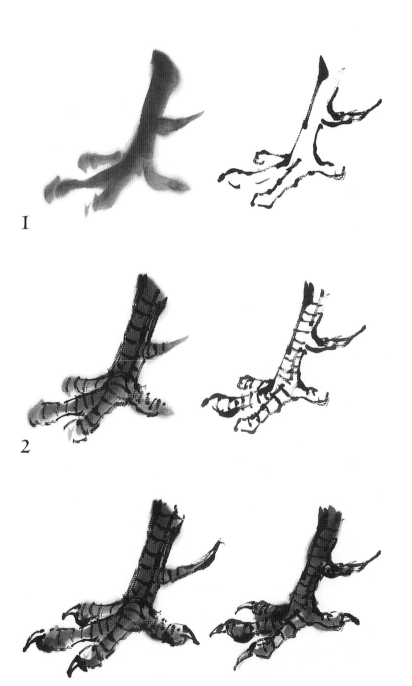

1

2

3

✵ MATERIALS

PAPER
Single-layer raw Shuan paper

BRUSHES
Medium soft fur • Small hard fur

CHINESE PAINTS
Ink • Vermilion • Yellow

1 Create a Basic Foot
Use the medium brush to mix Yellow, Vermilion and a little ink for a grayish-orange color. Hold the brush perpendicular to the paper and paint the left leg in several strokes. At the end of the toes add short strokes to emphasize the structure.

Load the small brush with dark ink. Blot the ink with a paper towel, to create a dry stroke. Outline the right leg. The dry strokes suggest a rough texture.

2 Add Outlines and Details
When the color is about 70 percent dry, use the small brush to outline the left leg with dark ink. Slightly vary the strokes in width. You don't need to paint continuous strokes; break some of them intentionally. In Chinese painting this is called *broken stroke with connecting tension*. The strokes on the upper portion are an example of this.

Use the same brush and dark ink to continue painting the details on the right leg.

3 Add Final Details
Use the small brush with dark ink to paint the claws and define the spur with single strokes on the left leg.

Use the small brush and dark ink to complete the claws and spur on the right leg. When the ink is about 70 percent dry, use the medium brush to mix Yellow, Vermilion and a little ink for a grayish-orange color. Apply the color within the outlines, but don't worry if your color is slightly outside them.

BEAR LEGS

In this demonstration, you will paint two bear legs in watercolor. Use wet-in-wet to capture the heaviness and mass of the legs. Use dry-on-wet to paint the lightness of the thick fur.

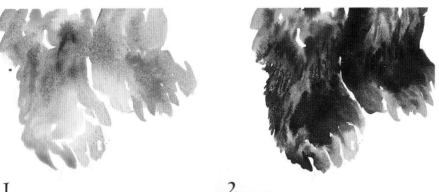

1

2

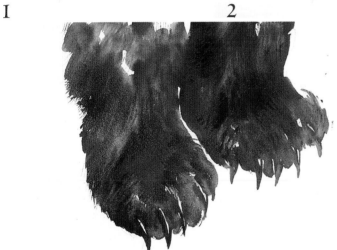

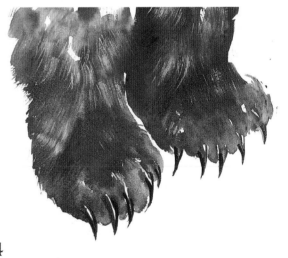

3

4

❀ MATERIALS

PAPER
140-lb. (300gsm) cold-pressed watercolor paper

WATERCOLORS
1-inch (25mm) flat • No. 4 round • Fan

PAINTS
Cadmium Red Deep • Cadmium Yellow Light • Ultramarine Blue

OTHER
No. 2 pencil

1 Add the Base Color to the Paper
Lightly sketch the bear legs and use a 1-inch (25mm) flat to wet them. Leave a few areas dry, such as at the upper portion of the toes and the legs. Apply Cadmium Yellow Light on the wet areas. Immediately apply Cadmium Red Deep on the yellow, mixing the colors into each other on the paper. This is the base color of the legs.

2 Define the Leg Shapes
Use the 1-inch (25mm) flat to make a dark brown mixture of Cadmium Red Deep and Ultramarine Blue with a touch of Cadmium Yellow Light. Paint the fur when the base color is still wet. Paint dark against light to get a strong contrast in color and value, as well as to define the shape.

3 Detail the Fur and Add the Claws
When the colors are about 50 percent dry, use the fan brush to spread the same dark brown color and further define the fur. Apply the strokes in the direction the fur grows. Finally, use the no. 4 round to create a thick dark blue mixture of Ultramarine Blue and Cadmium Red Deep. Paint the claws, leaving white highlights on their tops.

4 Add Final Details
While the colors on the legs are about 70 percent dry, use the fan brush to detail the light-colored fur with Cadmium Yellow Light. Pick up the pigment at the tip of your brush without water. Paint the fur in the direction it grows.

LLAMA HEAD IN SPONTANEOUS AND DETAIL STYLES

Let's paint a llama's head to explore the two basic Chinese painting techniques: spontaneous style and detail style. From painting the same subject in different styles you will more clearly see the differences between them. For a detailed explanation of these styles see page 20.

⚜ MATERIALS

PAPER
Single-layer raw Shuan paper

BRUSHES
Small and Medium hard fur

CHINESE PAINTS
Burnt Sienna • Carmine • Ink • Vermilion • Yellow

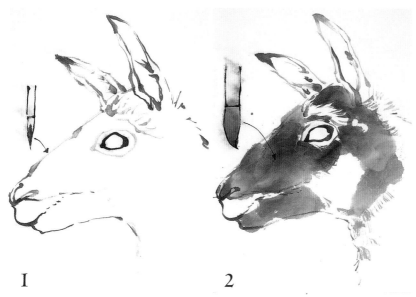

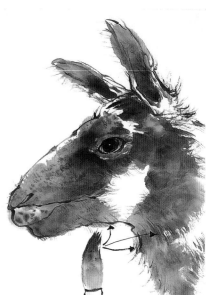

1 Sketch the Head
Load the small brush with ink and sketch the head. Use a variety of values and widths to suggest the textures and contours of the head. Apply wider strokes at the bases and tips of the ears to suggest texture and their connection to the top of the head. Use wider strokes at the upper part of the head to suggest its contours. Let dry.

2 Paint the Head
Soak a medium brush with Yellow, add Burnt Sienna and ink at the tip, Carmine in the middle and Vermilion almost to the heel. Hold it sideways, pointing the tip toward the eye. Paint a few strokes at the top of the head. Then point the tip toward the upper lip to paint the lower head.

3 Paint the Hair
While the colors are wet, load more ink onto the medium brush. Paint the hair on the nose and neck with ink **(A)**. Add a small amount of ink to the brush tip and dab it on a paper towel to make the tip split **(B)**. Paint the hairs on the nose with short strokes in the direction of hair growth. Use the same

brush to paint the eyeball with Yellow and a touch of Carmine on the upper part.

4 Add Final Details
Use the medium brush to paint more hair with darker ink. Try to finish the hairs before the colors are completely dry. On the mouth, use the small brush to get dark ink and paint

the spots while the colors on it are wet. Finish the eye by painting the pupil with dark ink, using the small brush. Leave a white spot at the central area for the highlight.

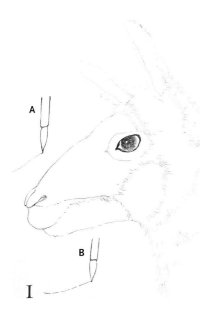

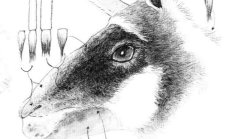

✿ MATERIALS

PAPER
Mature Shuan paper

BRUSHES
Small and Medium hard fur

CHINESE PAINTS
Burnt Sienna • Carmine • Ink • White • Yellow

1 Outline the Head and the Eye

Wet the small brush, lightly load it with ink and outline the head. Apply midtone value for most of the head. For the ring around the eye use a dark value and move your brush continuously, painting long strokes **(A)** but not broken ones **(B)**. At the pupil first apply light ink and then dark ink. Leave a tiny white spot on the pupil as a highlight.

2 Underpaint and Detail the Hair

Use the medium brush to lightly wet the areas where the darkest hair will be. Then load the small brush with ink and lay in midtones on the wet areas **(A and B)**. Apply darker ink on the darkest areas **(C)**. After the ink is dry, use the small and medium brushes to detail the hairs, first use light ink, then a midtone and finally dark. Split the tips of the brushes to get the detail effect for the individual hairs. Use your fingers or dab the brushes on a paper towel to make their tips split **(D** and **E)**.

3 Layer Colors

Apply several layers of color to the top and bottom of the head. Use the medium brush to paint the first layer with a light value Yellow. After it is dry, layer a light value Carmine on top of the Yellow. Let dry. Add Burnt Sienna on top. A common aspect of detail style is applying anywhere from three to nine

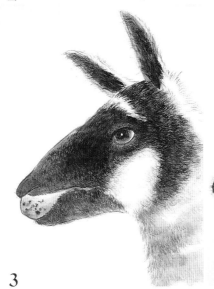

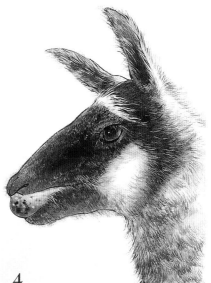

layers of color on the same area to achieve the detailed effect. The mature Shuan paper gracefully takes multiple colors.

4 Highlight and Finish the Hair

Use the small brush to highlight the hairs. Mix White and Yellow to paint the small hairs on the brightly colored areas. Mix White, Yellow and a little Carmine to paint the hairs on the darker areas. Use fresh White pigment and mix all the pigments with a very small amount of water.

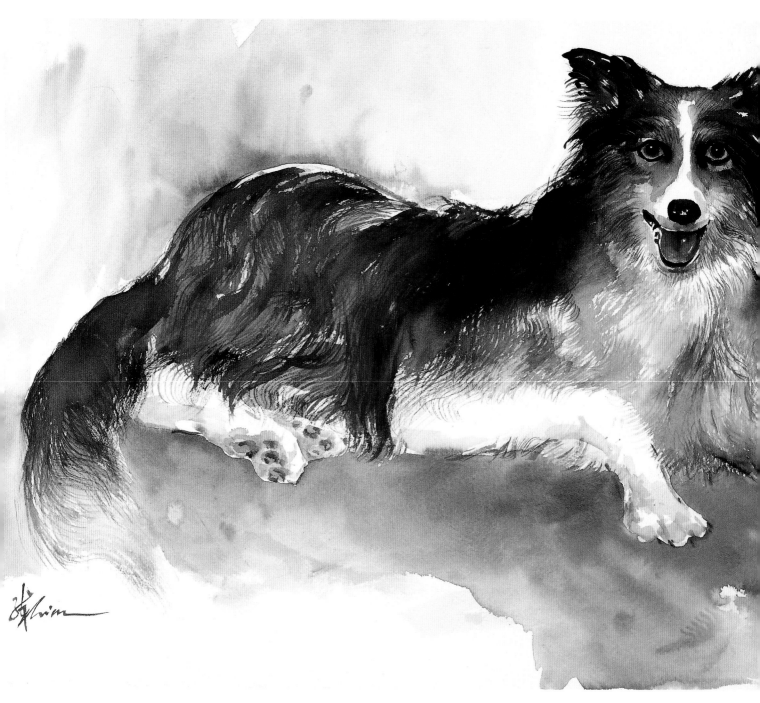

Dog *Watercolor* *11" × 15" (28cm × 38cm)* *140-lb. (300gsm) cold-pressed watercolor paper*

CHINESE & WATERCOLOR
DEMONSTRATIONS

Chinese paints and watercolor are both water media and they both have magnificent transparent effects. Artists have to learn to control and manipulate the water in order to master the techniques. In this chapter you will practice Chinese and watercolor techniques with step-by-step demonstrations. I will start with a few Chinese painting demonstrations and then move on to watercolor demonstrations. At the end of the chapter, I have chosen the same subject to paint with Chinese techniques and then as a watercolor so you can see the similarities and differences as well as the integration of the two styles.

When I was a beginner, I trashed most of my paintings because one or two strokes were wrong and I couldn't fix them. You may want to start with smaller paper and simpler objects, or even part of the object rather than a complicated painting. The more you practice, the better you are. Try not to force yourself to create masterpieces in the beginning. You're supposed to have fun. Happy painting!

CAPTURING THE ESSENCE OF ANIMALS

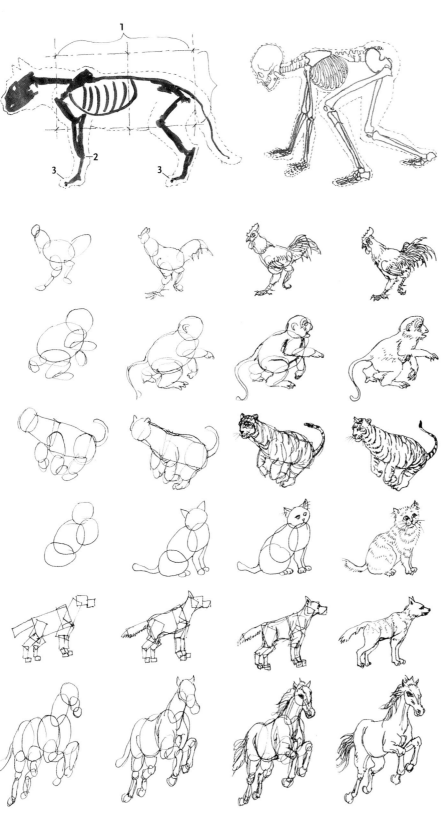

Learning Animal Anatomy

Animal anatomy is different from human anatomy. As an artist, it is more important to concentrate on significant characteristics and form, rather than to specifically focus on minute details. Here are three common characteristics of animal anatomies:

1. Body length is usually twice the size of the height.
2. Front legs are shorter because they support more weight.
3. Animals stand, walk and run on their *toes* rather than their *feet* like humans.

How to Sketch Animals

This shows you a simple way to sketch a rooster, monkey, tiger, cat, dog, and horse, using basic shapes. These shapes allow you to easily capture the characteristics of an animal's body. Start sketching with the body because it is the largest part of the animal and has less movement. Once you have constructed the basic shapes, start filling in the details.

SQUIRRELS

This simple spontaneous-style demonstration shows you how to use the brush to create strokes. Unlike watercolor paintings where many strokes are used for rendering surfaces, here you use a minimum number of strokes to suggest the shape and texture of the subject. Remember, each stroke counts.

⚘ MATERIALS

PAPER
10" × 15" (25cm × 38cm) single-layer raw Shuan paper

BRUSHES
Small and medium hard fur • Large soft fur

CHINESE PAINTS
Burnt Sienna • Carmine • Ink

OTHER
Soft Pencil • Soft charcoal

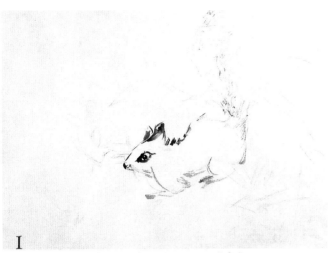

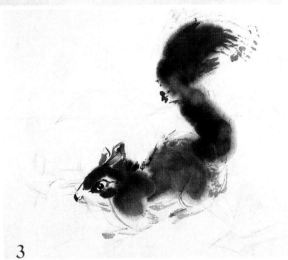

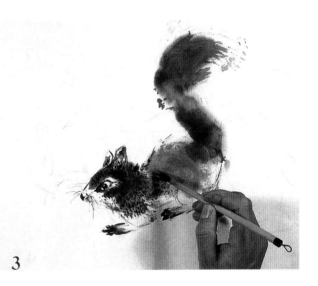

1 Sketch Two Squirrels
Use soft pencil or soft charcoal to lightly sketch two squirrels. Use the small brush to outline the front squirrel with a variety of ink tones. Also apply a variety of different strokes: Use dry strokes on the tail to depict the long fur and wet strokes on the ear and eye to suggest softness.

2 Paint the First Squirrel
Wet the large brush. Load it with midtone ink and then load its tip and middle area with dark ink. Hold the brush sideways and paint the head, body and tail in a few strokes.

3 Detail the Hair
When the strokes are about halfway dry, detail the hair with the small brush. Lightly wet the brush and load the tip with dark ink. Split the tip with your fingers or a paper towel. Move the brush fast, applying short strokes to the squirrel's body. If you move the brush slowly, the dark ink blends too much.

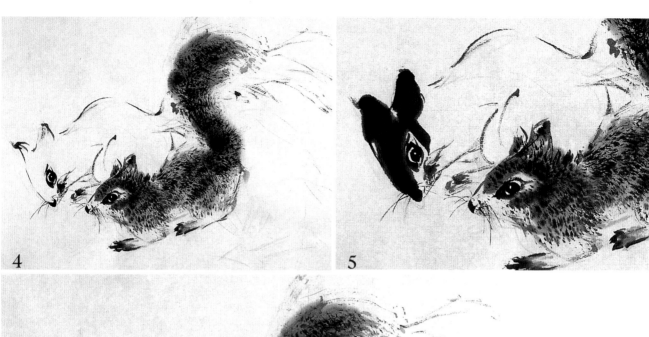

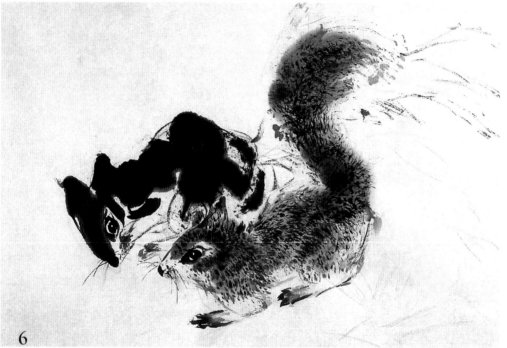

4 Outline the Second Squirrel
Sketch the background squirrel with the small brush and ink similar to the first one. Vary the ink tones.

5 Paint the Head and Nose
Lightly wet the medium brush and load it with a mixture of Burnt Sienna and ink; mix the colors in the brush. Also add a little dark ink on the tip. Hold the brush sideways with its tip toward the nose and paint the nose and head in one stroke. Then paint the ears in two strokes.

6 Paint the Body
Use the same brush and color to paint the body in about seven strokes.

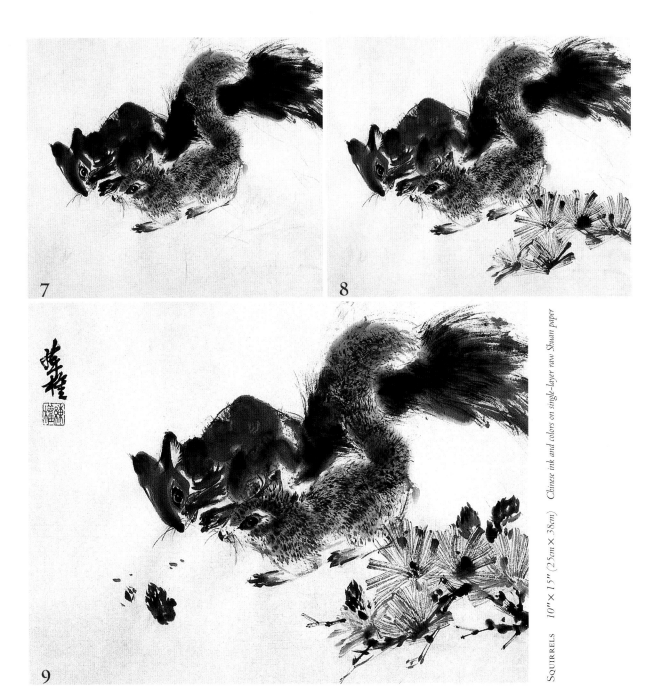

SQUIRRELS 10"×15" (25cm×38cm) *Chinese ink and colors on single-layer raw Shuan paper*

7 Paint the Tail and Add Dark Fur

Use the large brush to paint the tail with the same colors and minimum strokes. Use the small brush and dark ink to add dark fur on its back and tail. Use quick strokes with a split brush.

8 Form the Eyes and Pine Needles

Paint the eyes with the small brush. First apply Carmine then add a little Burnt Sienna. Dip the tip of the medium brush in dark ink and make it split. Paint the pine needles, brushing from the center toward the outside for each group.

9 Add Final Details

Use the medium brush and ink to accent the pine bushes. Mix Burnt Sienna and ink to paint the pinecones. I added the pinecone on the lower left for two reasons. First, to add a little curiosity on the theme—are the two squirrels talking about the pinecone or are they discussing who should get it? The second reason is to balance the composition by arranging objects: the squirrels and the pine tree branches are all overlapping each other but the pinecone is separate from them. Sign your name in the upper left corner and put your chop underneath it to balance the composition.

RHINOCEROS

This is another simple spontaneous-style painting. Like the last painting, you will use a minimum number of strokes and colors to capture the essence of the animal. I will also teach you how to control the water and ink in order to bleed the color from the edge of the rhinoceros into the background.

❊ MATERIALS

PAPER
11" × 14" (28cm × 36cm) double-layer raw Shuan paper

BRUSHES
Small and medium hard fur • Large soft fur

PAINTS
Carmine • Indigo • Ink • White • Yellow

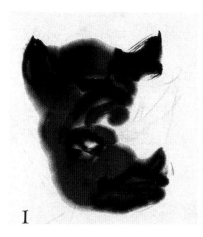

1 Paint the Face and Features
Lightly wet the large brush. Mix together Yellow and Carmine with a little ink. Hold the brush perpendicular to the paper and paint the head in a few strokes. Immediately use the brush to pick up more ink to paint the ears, the eye and the mouth.

2 Add the Horns
Use the medium brush to pick up dark ink to paint the horns. Hold the brush sideways and move it fast to get the broken strokes that depict the texture of the horns. Also use the same brush to complete the mouth and the head. Paint the pupil with very dark ink and leave a white spot as a highlight.

3 Paint the Body in a Few Strokes
Use the large brush to mix together Yellow and Carmine with a little ink. Paint the body in a few strokes. Leave whites between the neck and head, and between the legs and body. When the colors are wet, dip the tip of the brush in dark ink to define the details.

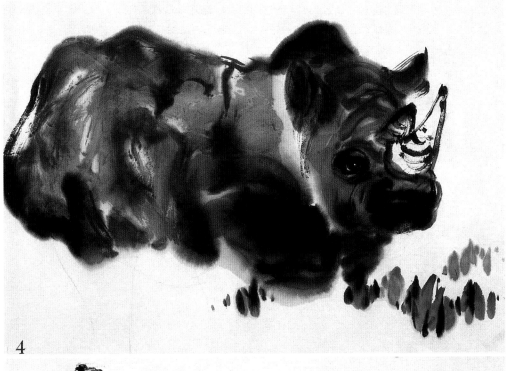

4

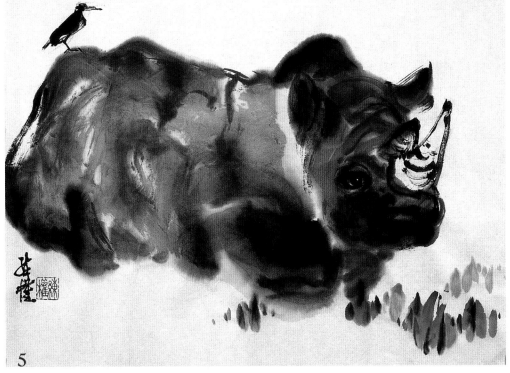

5

4 Highlight the Pupil and Create Water Plants

I lost the white highlight of the pupil because my brush had too much water in it and it overblended the ink and colors. Redefine the white spot with thick White. Next load a medium brush with Yellow and Indigo. Mix them a little in the brush to paint the water plants. While the color is wet, dip the brush tip in ink to paint one stroke on some of the leaves to define their shape.

5 Add Final Details

Use the small brush to paint the bird with dark ink in a few strokes starting with its body. Leave white at the wing. Now finish this simple painting using a minimum number of strokes to achieve maximum effects.

MONKEYS

This spontaneous-style demonstration illustrates one of the best characteristics of the style—simplicity. Simple is beautiful! In this painting you will use watermarks to create the shape and suggest the structure of monkeys. You will also learn how to leave whites, rather than using white paint to create hair.

✿ MATERIALS

PAPER
10" × 15" (25cm × 38cm) single-layer raw Shuan paper

BRUSHES
Small and medium hard fur • Extra large soft fur

CHINESE PAINTS
Carmine • Ink • Vermilion • White • Yellow

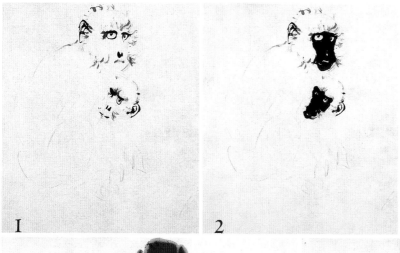

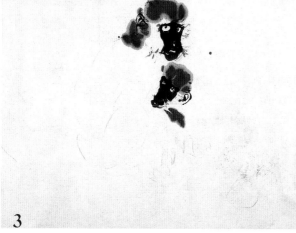
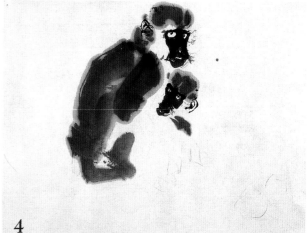

1 Outline the Heads
Use the small brush to outline the head, eyes, ears, nose and mouth on each of the two monkeys. Apply lighter ink for the hairs and darker ink for the features. Leave tiny highlights on each pupil.

2 Darken the Faces
Use the medium brush to mix Carmine, dark ink and a little Vermilion, making a very dark brown color. Apply the color on the faces. Use more dark ink around the eyes.

3 Paint Hair on the Heads
Lightly wet the extra large brush. Load Yellow first and then mix it with Vermilion, Carmine and a little ink on your palette. Avoid overmixing the colors or you will get a dirty color. Paint the top and back of the heads with a few strokes. Overlap the strokes to show the watermarks, creating illusions of hair texture. The yellow outline is the Yellow bleeding to the outside of the strokes. Make sure you don't have too much water in the brush, or it will blend too much.

4 Paint the Adult's Upper Arm and Back
Use the extra large brush to mix more of the hair color. Put more dark ink at the tip. Paint the adult's back and upper arm in a few big strokes.

5

6

7

5 Paint the Adult's Tail, Leg, Forearm and Hand

If the hair colors in your brush are used up, load the same colors again. Then paint the tail in one stroke from the body to its end. Pick up more dark ink on the brush tip to paint the leg, the forearm and hand.

6 Detail the Adult and Paint the Baby

Use the medium brush to define the adult's fingers, toes and the end of the tail with dark ink. Next, mix Vermilion, Carmine and ink to paint the body of the baby monkey with a few strokes.

7 Add the Eyes and Final Details

Use the small brush to paint the eyeballs with Yellow. Immediately add Carmine to the Yellow, creating an orange color. At the top of the eyeballs, paint the shadows with midtone ink. If you have painted over the pupils you originally created, wait until the eye colors are almost dry, then paint the pupils with very dark ink and add the highlight with White. Use the extra large brush to paint three peaches at the bottom right starting with Yellow then adding the Carmine. While the colors are wet, outline them with ink.

TIGER

You will use the *Bone* method to paint this tiger. First outline most of the object with ink and then paint the colors within the lines. You used this method when you painted the front squirrel on page 57.

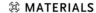

✿ MATERIALS

PAPER
12" × 16" (30cm × 41cm) single-layer raw Shuan paper

BRUSHES
Small and medium hard fur • Extra large soft fur

CHINESE PAINTS
Carmine • Indigo • Ink • Vermilion • White • Yellow

OTHER
Soft charcoal

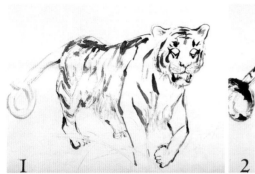

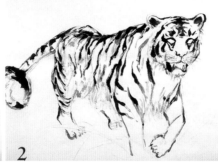

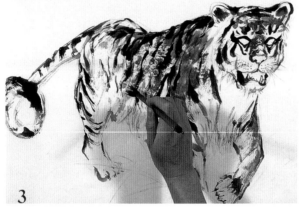

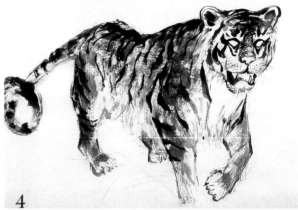

1 Sketch the Body and Weeds
Sketch the tiger and weeds with soft charcoal. Load the small brush with ink and paint the tiger from its head down through its body. Vary the stroke size and ink value to depict the textures. Apply broader strokes at the angles and use lighter ink on the long white hair areas.

2 Paint the Stripes, Ears and Tail
Use the medium brush to paint the stripes with dark ink. Add more ink strokes to the ears and tail.

3 Add Tone and Texture to the Fur
Load the medium brush with midtone ink. Blot it on a paper towel to remove the excess moisture. Paint the tone and texture of the fur. Then use your finger to split the tip of the brush. Hold your brush slightly sideways to paint the fur.

4 Add Darker Values
Use your medium brush to apply a darker tone of ink on top of the head, back and on the right of the legs. These darker values create a 3-D effect. Let dry.

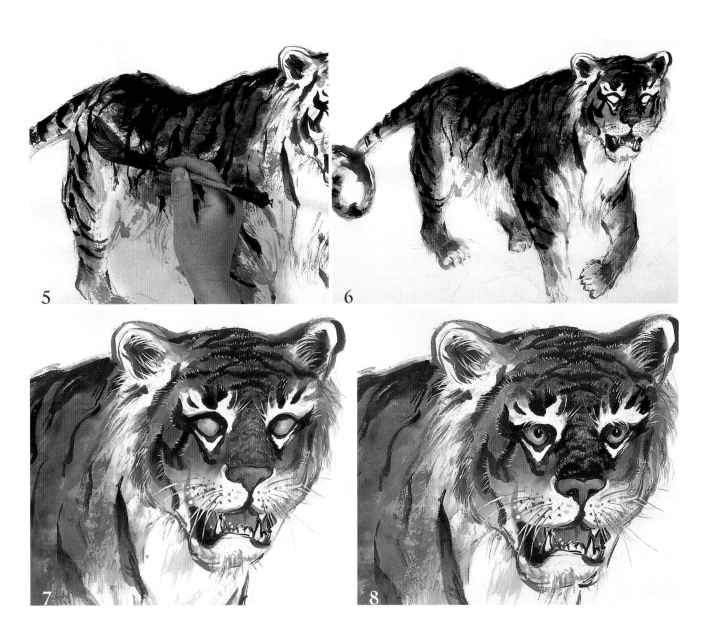

5 Add Colored Areas

Mix the Yellow, Carmine and ink into a brownish color in the extra large brush. Paint the colored areas of the tiger starting with the body. Hold your brush sideways and paint with large, broad strokes.

6 Paint the Face, Nose and Tongue

Continue painting the tiger's body with the extra large brush. Leave white to depict the white fur. Mix the Yellow, Carmine and ink into a brownish color on the medium brush to paint the the face. Load Carmine and Yellow onto the small brush to paint the nose and tongue.

7 Paint Eyes and Add Details

Use the small brush to paint the eyes with Yellow and Vermilion, leaving small white spots for the pupil highlights. Paint the white fur in the ear and the whiskers with thick White. Mix a little Yellow with thick White to highlight the fur in the ear.

8 Finish the Eyes

Paint the pupil with dark ink. Mix Carmine and a little ink to paint the upper eye shadow. Use thick White pigment to paint the eyebrow fur and add the highlight to the pupil.

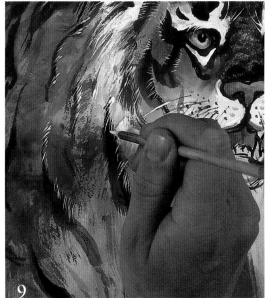

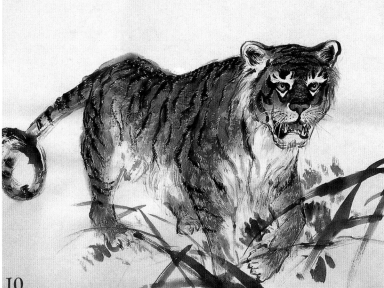

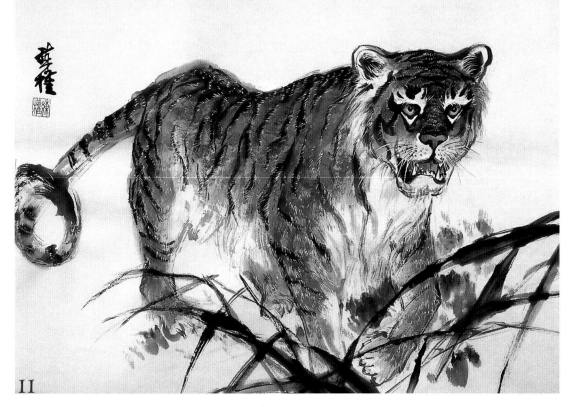

Tiger 12" × 16" (30cm × 41cm) Chinese ink and colors on single-layer raw Shuan paper

9 Add Highlights
Highlight the lightest areas of fur with White and the darker areas of fur with a light Yellow.

10 Paint the Weeds
Use the medium brush to mix Yellow, Vermilion and a little ink into a brownish color; lightly mix Yellow, Indigo and ink into dark green color on your palette without over-mixing them. Paint each weed in one or two strokes. Mix the brownish color with ink to paint several strokes between the two front legs outlining and contrasting the white fur, as well as suggesting the ground.

11 Add Final Details
When the weeds are still wet, paint veins on them using dark ink and the small brush.

HORSES

In this spontaneous-style demonstration you are painting with the *No Bone* method. There is no outline on the horses before you apply the colors and ink. You will use large strokes to illustrate the large parts of the bodies.

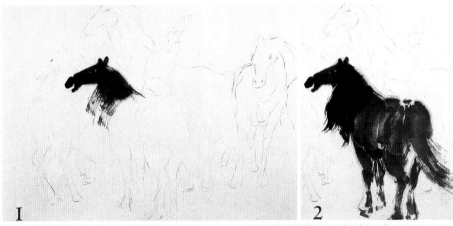

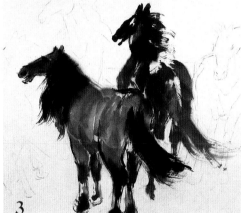

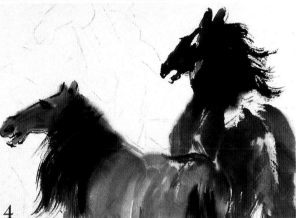

MATERIALS

PAPER
12" × 16" (30cm × 41cm) double-layer raw Shuan paper

BRUSHES
Small hard fur • Medium soft fur

CHINESE PAINTS
Carmine • Indigo • Ink • Rouge • Vermilion • White • Yellow

OTHER
Soft charcoal

1 Sketch Horses and Paint the Head and Mane

Sketch the horses with soft charcoal. Use the medium brush to thinly mix Indigo, Rouge and ink. Paint the head holding the brush perpendicular to the paper. Paint the mane using diagonal strokes from right to left holding the brush sideways. Using the side of the brush for the mane creates a broken effect suggesting hair.

2 Create the Body of the First Horse

Paint the body of the first horse with the same color mixture, using a few brushstrokes. Overlap the strokes to create watermarks between them. The watermarks suggest the shape of the animal. Paint the tail with a couple of strokes, using the side of the brush. Pick up more ink with the medium brush to paint the legs from its body to its toes.

3 Detail the First Horse, Paint the Second Horse

When the first horse is about 50 percent dry, pick up dark ink with the small brush, hold it sideways and detail the hair on the mane and tail. Add more dark ink to the brush and outline the left legs, emphasizing the joints. Mix Carmine, Rouge and ink in the medium brush to paint the second horse, starting at its head. Leave some white on the top of its back.

4 Detail the Head and Mane of the Second Horse

Load the small brush with dark ink. While the second horse is still wet, define the details on its head and mane. Notice how the color on the first horse appears much lighter now. This is similar to the way watercolors seem lighter after they have dried.

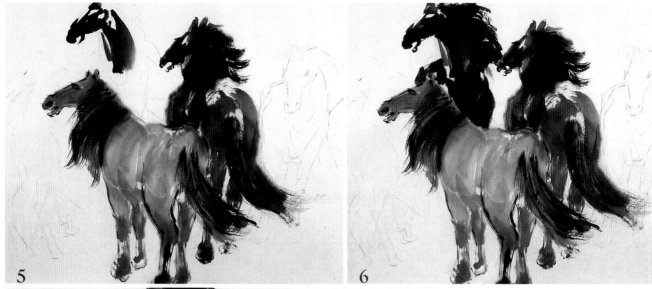

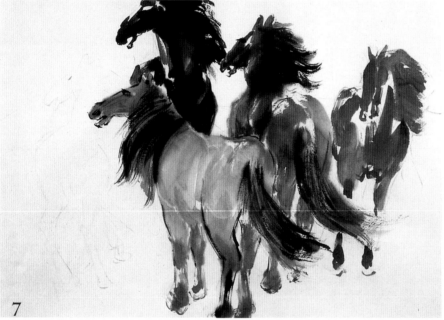

5 Detail the Tail of the Second Horse, Paint the Third Horse

Load the small brush with dark ink to define the shape of the tail on the second horse. Next paint the third horse with the medium brush and the same colors you used for the second horse. Paint from the head to the neck with a few brushstrokes, just capturing the character of the animal.

6 Define the Edges of the Horses

Use dark ink on the medium brush to paint the mane of the third horse. Add dark ink into the border of the first and third horses to make them each stand out. Leave a little white on top of the neck and head of the first horse to suggest highlights.

7 Paint the Fourth Horse

Use the medium brush to paint the fourth horse. Mix together Yellow, Vermilion, Carmine and ink. Paint the animal in simple strokes.

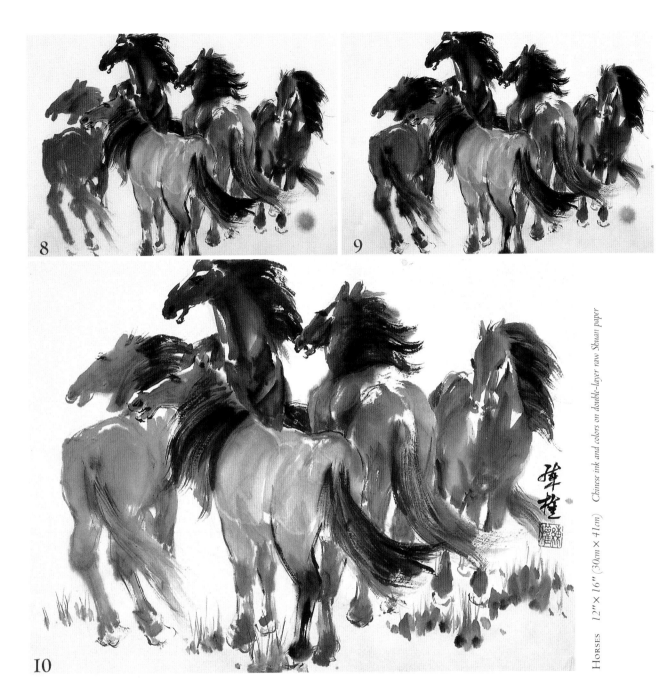

Horses 12" × 16" (30cm × 41cm) *Chinese ink and colors on double-layer raw Shuan paper*

8 Detail the Fourth Horse and Paint the Fifth Horse

While the fourth horse is still damp, use the small brush to paint its mane, tail and define its overall shape in a few strokes. Add more Carmine to the medium brush and paint the fifth horse. Notice how I accidentally dropped some light brown paint in the bottom right of the painting. I didn't worry about it because I just made it part of the ground texture. This is what painters refer to as a "happy accident."

9 Detail the Fifth Horse

Load the small brush with dark ink to paint the tail and mane and define the body of the fifth horse. I was going to leave white between the fifth horse and the top of the first horse's head, but the ink blended too much, so I used White to clean it up.

10 Add Final Details

Use the medium brush to mix Indigo, Yellow and ink and paint the grass. Hold the brush straight to paint the round strokes first. Use the small brush to paint the grass on top of them. When the fifth horse is dry, highlight the top of its head with a few strokes of White.

ELEPHANTS

In this demonstration I will teach you the *Color Pouring and Blending* technique to paint elephants. If you paint with the traditional method, you can use large brushes to create washes for the foreground and background. Pouring the colors on the paper gives you an unexpected but very beautiful blending effect. There are no brushstrokes so the foreground and background colors smoothly reflect each other—great for illuminating and diffusing landscapes. Pouring also creates a unified color scheme for the entire painting.

MATERIALS

PAPER
140-lb. (300gsm) cold-pressed water-color paper, half sheet

BRUSHES
1-inch (25mm) flat • Nos. 4 and 8 rounds

WATERCOLORS
Cadmium Yellow Light • Permanent Red Deep • Ultramarine Blue

OTHER
Masking fluid • Paper towels • Pencil • Three small dishes (containing the three midtone primary color liquids) • Table salt • Spray bottle • Packing tape

Preparing Colors for Pouring

Mix each of the three primary colors with water in three small cups. Stir the colors with brushes until they completely dissolve in the water. There are two rules for making the color liquids: (1) The darker the background, the more pigment; the lighter the background, the more water. (2) Never mix the Yellow lighter than its midtone or it will be muddy after the colors mix with each other. For most of the color pouring demonstrations in this chapter, prepare midtone color liquids. The ratio between color and water is approximately 1 to 15.

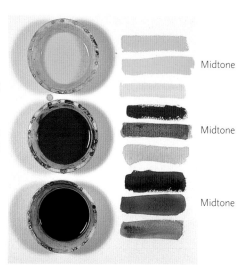

Midtone

Midtone

Midtone

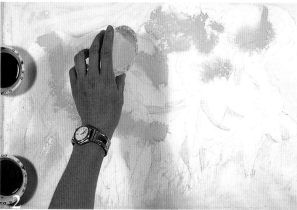

1 Sketch the Composition and Mask Out Negative Space

Sketch a group of elephants onto your paper, leaving room for grass in the foreground and sky in the background. Block the negative spaces with masking fluid: the sky and the spaces between the elephants (see page 19 for applying masking fluid). Also mask the trunks and the foreground grasses. After the masking fluid dries, wet the paper with water using the spray bottle. This allows the colors to gracefully blend into each other.

2 Pour the First Color

I would like to create a warm background—either a sunrise or sunset—so I will use more Cadmium Yellow Light and Permanent Red Deep than Ultramarine Blue. First pour the Cadmium Yellow Light on the tops of the elephants' heads and bodies.

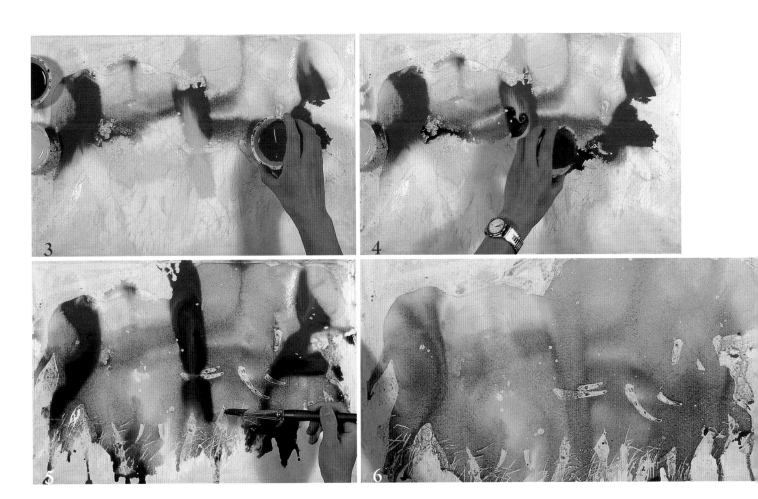

3 Pour the Second Color

Immediately pour the Permanent Red Deep next to the Cadmium Yellow Light. Let the colors blend into each other. Help the colors blend by spraying more water on them, blowing them into each other, and using a large brush like the 1-inch (25mm) flat or the no. 8 round to mix them together.

4 Pour the Third Color

Pour the Ultramarine Blue below the Permanent Red Deep, on the middle and lower parts of the elephants. Try to create a darker color value here.

5 Direct the Colors and Avoid Mud

Direct the blending of the colors around the paper with a 1-inch (25mm) flat. Also use the brush to bring the colors to the bottom part of the painting. Do not brush too much in one spot or you will overmix the colors and make that area muddy.

6 Tilt the Painting

Tilt your painting down toward you so the colors flow down the paper. This gets rid of the excess liquid while letting the colors mix gracefully. Tilt the paper in one direction only or your painting will get muddy.

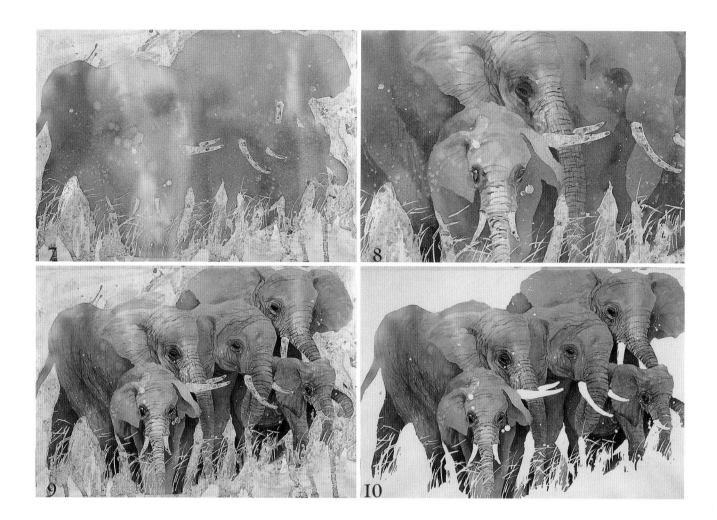

7 Add Texture

As you are tilting the painting, spray water from the top of the painting down, creating light rays. Drop some table salt on the painting to create a dusty effect. Notice this effect on the bottom of the elephants.

8 Define the Elephant Shapes

When the painting is dry, use the nos. 4 and 8 rounds to define the shapes of the elephants. Use the no. 4 round to paint and the no. 8 round to blend the colors. Apply colors that are darker than the existing colors to create the details. Use brown and dark brown on the elephant foreheads because the original color is orange.

9 Enhance the Details

Apply darker values to contrast the light values so the elephants stand out.

10 Remove the Masking

After the paint dries, remove the masking. You can use a masking pick-up eraser. I use 1- to 2-inch (25mm, 51mm) pieces of packing tape. Hold the nonadhesive side of the tape with your thumb and index finger and press the adhesive side against the masking and pull it up.

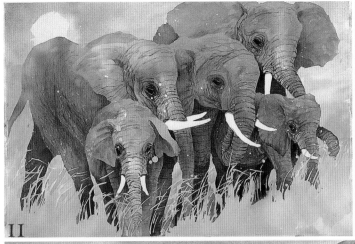

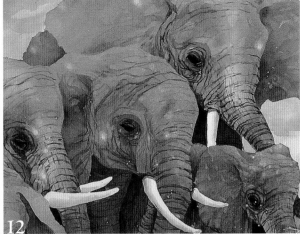

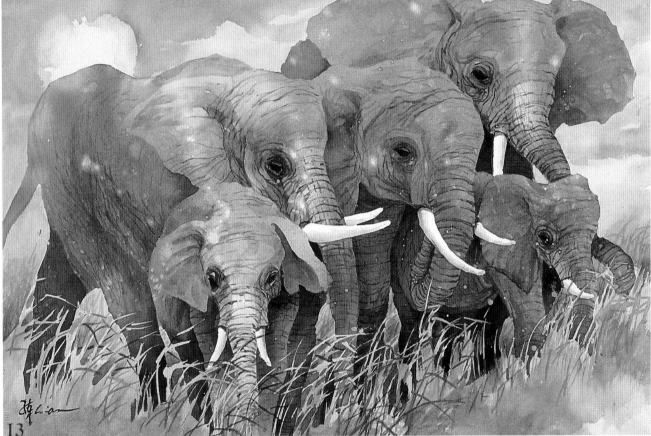

11 Paint Sky and Grass

Wet the sky and the grass area with the 1-inch (25mm) flat. Leave a circular area dry on the upper left for the sun. Paint the sky using a mixture of Cadmium Yellow Light and Permanent Red Deep. Paint the grass with Cadmium Yellow Light.

12 Create Dust

Use a paper towel to soften the hard edges of the salt spots (added in step 7) near the eyes of the elephants. Wet the towel and use it to scratch the white spots until the hard edge is gone, giving the impression of dust.

13 Add Final Details

Use the no. 4 round to paint the brownish grass in the front and the purplish color in the background. Sign your name at the lower left corner, not the right corner, because the elephants are walking toward the right and the composition needs space for their movement.

TURTLE

In this demonstration you will learn the *Blowing to Paint* technique. You will use this to blow the color liquids with your mouth to create the background grass. The key to successfully using this technique to create the grass is to get very close to the colors and blow very hard and fast.

❊ MATERIALS

PAPER
140-lb. (300gsm) cold-pressed water-color paper, half sheet

BRUSHES
½-inch (12mm) and ¾-inch (19mm) flats • Nos. ½, 2 and 4 rounds

WATERCOLORS
Antwerp Blue • Cadmium Red Deep • Cadmium Yellow Light

OTHER
No. 2 pencil • Masking fluid • Three small dishes (containing the three midtone primary color liquids) • Paper towels • Spray bottle

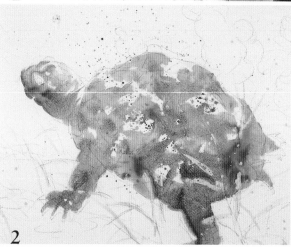

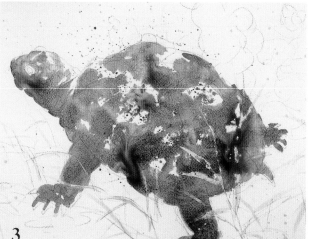

1 Sketch the Composition
Lightly sketch the turtle, grass and cactus with a no. 2 pencil. It is not easy to create a good composition with a turtle because of its round shape. Here I placed it toward the right leaving more area on the left for it to move (see page 77). Use the handle of the ½-inch (12mm) flat to apply masking fluid on the foreground grass. Apply it carefully to get the shapes of the vegetation. Use the ¾-inch (19mm) flat to wet the turtle with clear water, leaving dry areas as highlights. I have added a pink tint to the water to show you where I applied it.

2 Blend Colors on the Turtle
Use the same ¾-inch (19mm) flat to pick up Cadmium Yellow Light. Apply it on the wet area of the turtle and splash it on the shell. Let the color blend into the wet surface. While the yellow is wet, use the same brush to apply the Cadmium Red Deep in the same way. Let both of the colors blend into each other.

3 Add More Color to the Turtle
Immediately use the same brush to apply Antwerp Blue on the turtle in the same way that you applied the other two colors. Let the three colors mingle to create the color-ful body. If you have too much liquid on the turtle, lift the color with a paper towel.

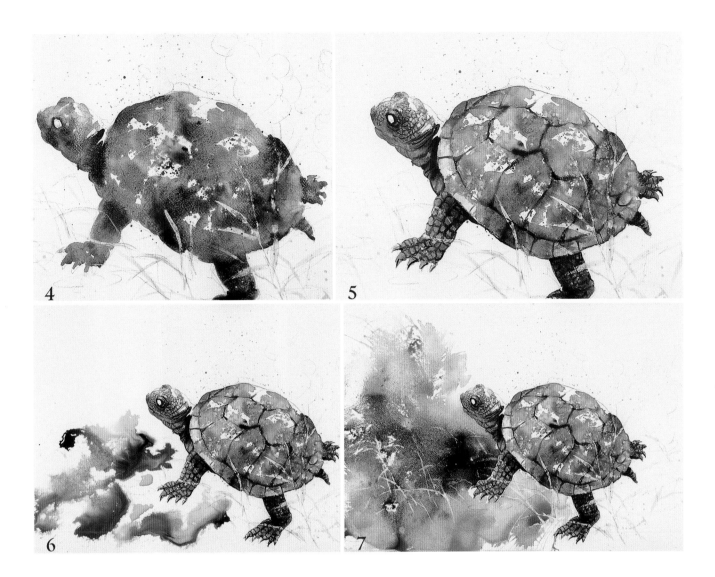

4 Add Darker Values

When the colors are about 60 percent dry, use the ½-inch (12mm) flat to create a dark blue mixture of Antwerp Blue and a little Cadmium Red Deep. Paint the eye ring, the neck, edges of the shell and the areas between the legs and the shell. This creates a strong value contrast in those places.

5 Define the Body

When the colors are about 80 percent dry, use the no. 2 round to create a dark blue mixture of Antwerp Blue and a little Cadmium Red Deep. Define the texture of its shell, neck and legs. If the dark blue colors blend from the legs into the shell, lift them with a paper towel. If some of the dark blue color lightens, use the no. 2 round to paint the details one more time. Now the colors on the head are almost dry. Define the details there in a similar way you did for the legs.

6 Pour the First Three Colors

Wet the left side of the background before you pour the colors. Use the ¾-inch (19mm) flat to wet the area near the turtles, and a spray bottle for all the other areas. Do not let the water touch the turtle. Pour the Yellow on the wet areas first and follow it with the Red and the Blue.

7 Blow the Colors to Create Grass

Use your mouth to blow the colors onto the upper left and lower middle of the painting to create the illusion of grass. Place your mouth very close to the colors and blow hard and fast. You may use a straw, but the result is not as good.

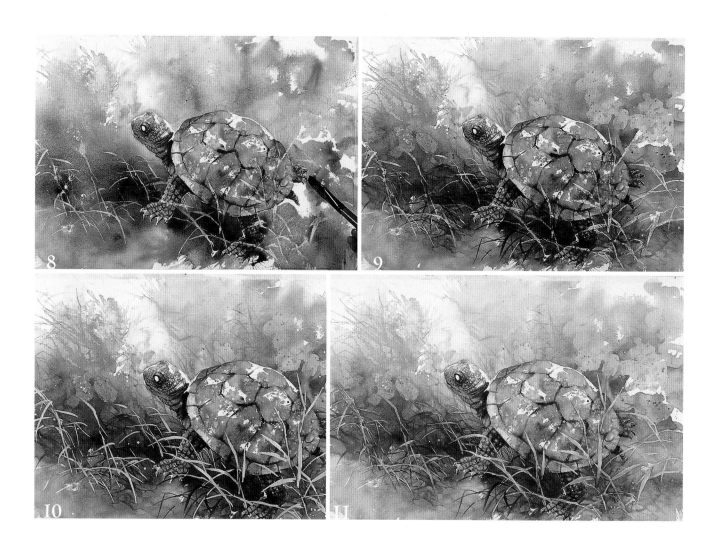

8 Pour the Colors on the Right Side

Wet and pour the colors on the right just like you did on the left except use more Yellow and Blue liquids because you want to create a cactus. On the area near the turtle use the ¾-inch (19mm) flat to guide the color liquids to the edges of the shape. Also use the same brush to paint dark Blue and Red in front and below the turtle.

9 Define the Cactus

When the colors are about 80 percent dry, use the no. 2 round to paint individual grasses, darker colors at the foreground and lighter at the distance. Define the cactus using the ½-inch (12mm) flat to paint around the cactus with similar but darker colors than the cactus, then use the ¾-inch (19mm) flat to blend the darker color into the background with a little water. To create the impression of the needles, use the ½-inch (12mm) flat to splash some colors onto the cactus.

10 Paint the Foreground Grass

Let colors completely dry; then remove the masking. There is only a little masking on this painting so you can use your finger to remove it; you can also cut packing tape or masking tape into a small piece, press it down on the masking and drag the masking off the watercolor paper. After lifting up the masking, the foreground grass is white. Use the no. 4 round to paint it with Cadmium Yellow Light. It is OK if the color gets on the outside edges of the grass.

11 Add More Color to the Grass

Apply Blue from the bottom to the upper middle of the grass. Apply the Red at the tip of the grass. The colors on the bottom of the grass are darker than the middle and tip.

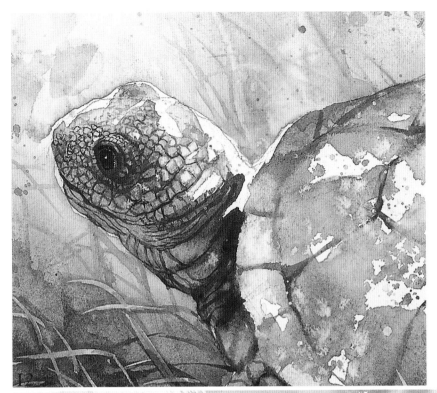

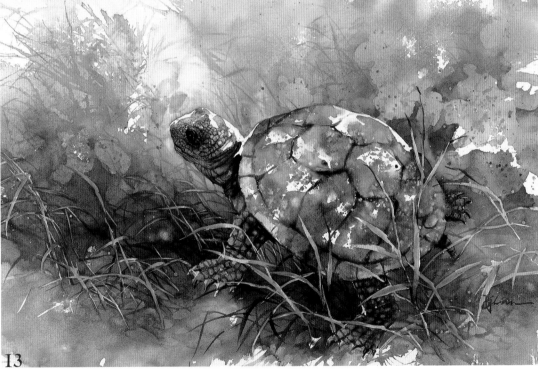

12 Add More Detail to the Head

Use the no. ½ round to define its texture. Add lighter colors to the top of the head and and vice versa. For the eyeball, paint a Red ring with darker red on the top. Finish the eye, using the no. ½ round to pick up a thick, almost black mixture of Antwerp Blue and a little Cadmium Red Deep. Paint the pupil leaving white as a highlight.

13 Add Final Details

Sign your name on the painting. It should not be on the lower left because the turtle is moving in that direction and you must leave room for it in the composition. Let's sign on the lower right corner.

EGRETS

In this demonstration you will use the *Color Pouring and Blending* technique to paint the two egrets. Notice how the sunrise illuminates the colors on the water and the weeds—all blending into each other forming a harmonious scene.

✿ MATERIALS

PAPER
140-lb. (300gsm) cold-pressed water-color paper, half sheet

BRUSHES
1½-inch (38mm) flat • Nos. ½, 2 and 4 rounds

WATERCOLOR
Antwerp Blue • Cadmium Red Deep • Cadmium Yellow Light

OTHER
No. 2 pencil • Masking fluid • Three small dishes (containing the three midtone primary color liquids) • Spray bottle

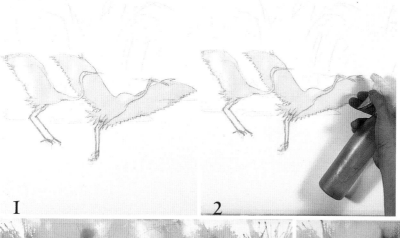

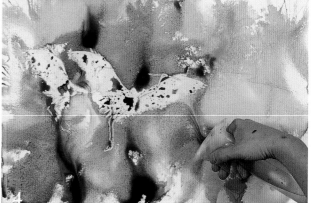

1 Sketch and Mask the Birds
Use a no. 2 pencil to lightly sketch the birds and weeds. Cover the birds with masking fluid. Let the masking fluid dry.

2 Saturate the Paper
Spray clear water to just lightly wet the paper without making puddles. Leave the upper and lower right corners dry. Plan to have the sun on the upper corner and the reflection on the lower right. This should be a sunrise or sunset scene. However, after pouring the three color liquids on the paper, you may get a raining or evening effect. It is OK, have fun and work with what you have.

3 Start Pouring the Colors
Pour the Yellow on the upper part of the painting starting from the right side where the sun is rising or setting. Then pour Red on the upper right and middle. Let the colors blend into each other. Use your mouth to blow the liquids toward the upper edge of the painting to get the weeds. You have to get very close to the color liquids and blow hard and fast.

4 Add the Blue
Pour Blue on the middle and left. If your colors are not running into each other, you should spray more water on them. Also, blow the colors to create more weeds and a reflection.

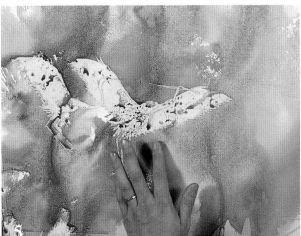

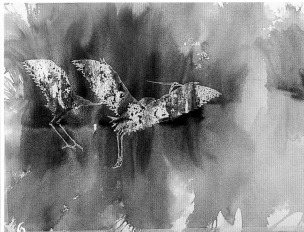

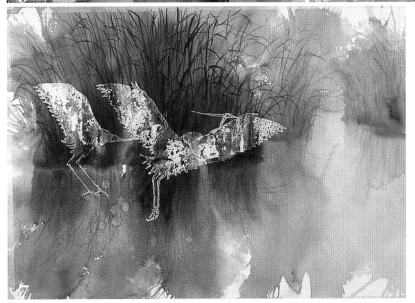

5 Blend the Colors

Tilt the upper right corner of the painting up high to let the color liquids flow from upper right to lower left. It allows the colors to blend into each other a little more. Also it creates the impression of light beams. The color liquids may not flow over the masking; use your finger or a brush to direct them over the masking.

6 Paint the Weeds

Use the 1½-inch (38mm) flat to create a dark mixture of Blue and Red; paint the group of weeds behind the birds. Move your brush from the bottom of the weeds up to the tips of the grass. Paint the reflection of the weeds moving the brush from the bottom of the weeds to the water. Pick up a little Yellow and Red to paint the weeds on the right—the further away the weeds are, the lighter and warmer the colors.

7 Paint the Grass

When the colors on the weeds are about 50 percent dry, use the no. 4 round to paint grass with the dark mixture of Antwerp Blue and a little Cadmium Red Deep. Follow the direction of the weeds to paint them. Use the same brush to paint the distant weeds the same way with lighter colors—using more water and less pigment. The farthest weeds should have warm colors similar to the sky behind them. Also, paint their reflections using lighter colors than the weeds above. Finish the weeds before the colors dry because you want them to blend a little into the background.

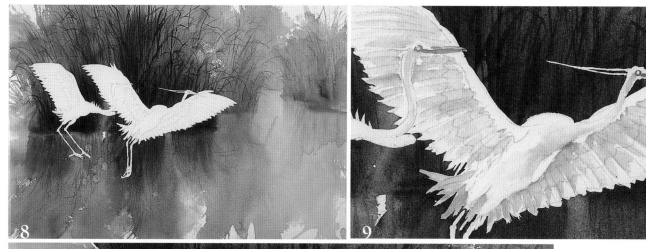

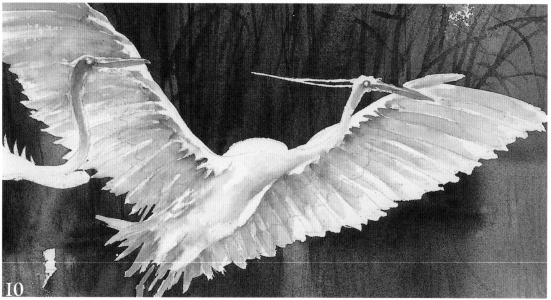

8 Lift the Masking
Wait for the painting to completely dry. Lift up the masking by using a piece of masking or packing tape. Hold the tape with your fingers, press it down to attach the masking and drag the masking away from the watercolor paper.

9 Paint the Birds
Paint the birds using the no. 2 round for applying colors and the no. 4 round for blending. Paint a thin layer of Cadmium Yellow Light on the eye and beak; then add a little Cadmium Red Deep. Use the no. 4 round to slightly wet the wings, neck and body. Use the no. 2 round to apply light colors for the feathers. Apply darker colors to the bone area of the wings. Even though the birds are white, they reflect the colors of the sky and water. Therefore we should apply some colors from their environment on them.

10 Add Darker Values to the Birds
After the colors on the wings dry, define more details by painting darker values. Leave some of the feathers' edges white. Now the contrast between light and dark is much stronger, as well as the 3-D appearance of the birds.

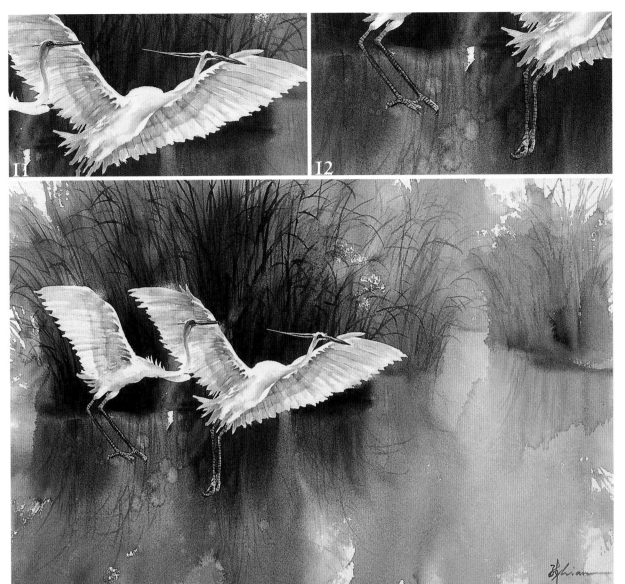

EGRETS *Watercolor 11″ × 15″ (28cm × 38cm) 140-lb. (300gsm) cold-pressed watercolor paper*

11 Paint the Beaks and Eyes

Use the no. ½ round to add more Cadmium Red Deep on the lower beak and upper part of the eye. Create a thick, dark blue, almost black, mixture of Antwerp Blue and a little Cadmium Red Deep. Paint the pupil, leaving a tiny white highlight. Also paint the joints between the upper and lower beaks with this color.

12 Paint the Legs

Use the no. 4 round to apply Cadmium Yellow Light on the knees and toes; then apply Antwerp Blue in the middle. When the colors are almost dry, add Cadmium Red Deep on the knees, lower part of the legs and at one side of the toes. Let the colors dry about 80 percent. Use the no. ½ round to create a dark blue mixture of Antwerp Blue and a Cadmium Red Deep to paint the texture.

13 Add Final Details

Sign your name on the lower left because that area is empty and needs objects to fill it.

FROGS

In this demonstration you will be painting frogs using the wet-in-wet technique. You will know when you are doing wet-in-wet because I will tell you to paint immediately from color to color. You will also try your hand at creating close-up details on the frogs' bodies.

❇ MATERIALS

PAPER
140-lb. (300gsm) cold-pressed water-color paper, half sheet

BRUSHES
1-inch (25mm) flat • Nos. 4 and 8 rounds

WATERCOLORS
Cadmium Yellow Light • Permanent Red Deep • Ultramarine Blue

OTHER
No. 2 pencil

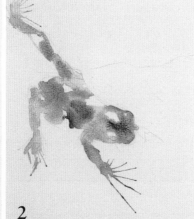

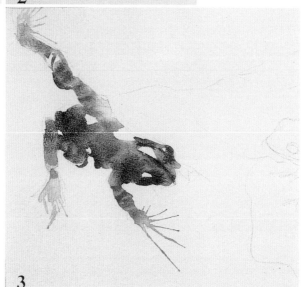

1 Lay a Base Color for the First Frog
Lightly sketch this composition of two frogs and lily pads. Use the no. 8 round to wet the frog on the left leaving small dry areas on top of its head and body for highlights. Use the no. 4 round to apply Cadmium Yellow Light on the wet areas.

2 Create Fingers and Toes
Immediately use the no. 4 round to paint Permanent Red Deep on the head, body and legs. Use your mouth to blow the colors on the feet and hands, creating toes and fingers. I do not get a planned amount of toes and fingers, but that's OK because I just want the impression of a frog and movement, not an exact replica of a frog.

3 Paint the Stripes
Mix Ultramarine Blue and Permanent Red Deep using the no. 4 round. Paint the stripes on the legs and define the head and the eye socket.

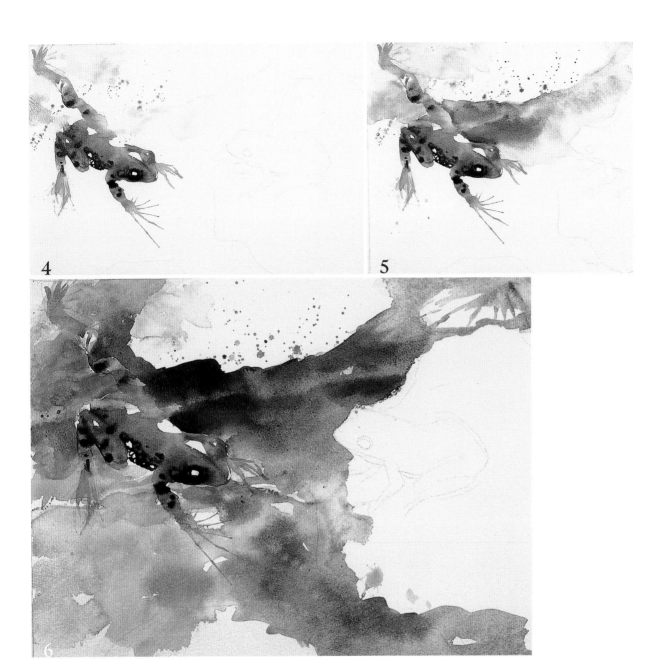

4

5

6

4 Blend Frog into Water

Mix thick Ultramarine Blue with a little Permanent Red Deep into very dark blue—almost black—using the no. 4 round. Paint some stripes and the eye socket again. Next wet the area above the frog with the 1-inch (25mm) flat, just barely touching the frog on its back and rear end. This allows the colors on the frog to slightly flow into the water, suggesting that the frog is swimming.

5 Create the Water

Apply Ultramarine Blue with the 1-inch (25mm) flat and drop Cadmium Yellow Light and Permanent Red Deep on top of it to create the water. You do not need to mix the colors on your palette, instead blend them on the paper.

6 Add Depth to the Water

Continue to paint the water areas below and in front of the frog in the same way. Leave white at the top of the page for the lily pad. While the colors are still wet, use the 1-inch (25mm) flat to create a dark mixture of Ultramarine Blue and Permanent Red Deep. Darken the water above the frog. This creates more depth in your painting. Drag the colors of the water over the frog's upper-left leg to enhance its motion, as well as integrate it with the water.

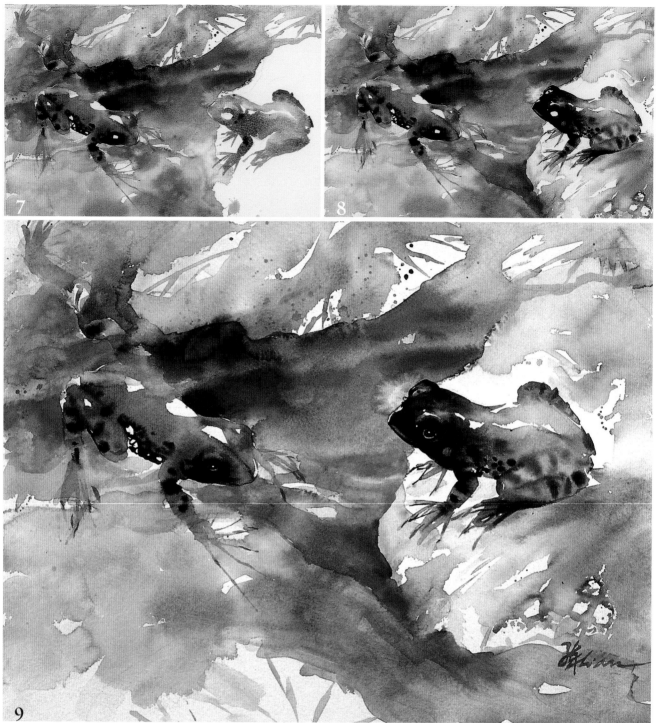

FROGS Watercolor 11" × 15" (28cm × 38cm) 140-lb. (300gsm) cold-pressed watercolor paper

7 Paint the Lily Pads and the Second Frog

Use the 1-inch (25mm) flat to paint the lily pads at the top. Wet them with water and then apply a thin layer of Cadmium Yellow Light, with a little Permanent Red Deep and Ultramarine Blue. Leave whites for highlights. Next, wet the frog on the right with the no. 8 round. Leave dry areas on its head and back. Apply Cadmium Yellow Light on the wetted areas then add Ultramarine Blue on its head and hand. Paint a little Permanent Red Deep on its rear end. Mix the three primary colors into a brownish pigment and paint the legs.

8 Paint the Lily Pad and Define the Second Frog

Use the 1-inch (25mm) flat to paint the lily pad on the lower right. Wet it with water, then apply a thin layer of Cadmium Yellow Light, with a little Permanent Red Deep and Ultramarine Blue. Leave whites for highlights. Keep the colors lighter than the frog and the water. Create a thick dark mixture of Ultramarine Blue and a little Permanent Red Deep and define the head, eye socket, stripes, patterns on the stomach and leg of the frog using the no. 4 round.

9 Paint the Eyes

Paint the eyes on both frogs first with Cadmium Yellow Light and then stroke Permanent Red Deep on the upper part of the eyes using the no. 4 round. Paint the pupils with a dark mixture of Ultramarine Blue and a little Permanent Red Deep. Leave a little white spot as a highlight.

DOGS

This spontaneous-style demonstration shows you how to use dark against light to define objects—a common technique in Chinese painting as well as watercolor. Notice how the middle dog is a light value while the other two are dark. The black dog behind the other dogs forms the outlines of the middle one. We don't always need to outline objects, values can to do the job instead.

✿ MATERIALS

PAPER
18" × 26" (46cm × 66cm) double-layer raw Shuan paper

BRUSHES
Small fur • Medium and large soft fur

CHINESE PAINTS
Carmine • Ink • Vermilion • Yellow

OTHER
Soft charcoal

1 Sketch Three Dogs
Sketch three dogs with soft charcoal. Start painting the middle dog first. Use the small brush to outline the eyes, nose and mouth with ink.

2 Paint the Head of the First Dog
Load the medium brush with the following colors: Vermilion up to the heel, Carmine from the tip to the middle, and a little ink on the tip. Paint the left side of the head. Apply more pressure around the eye and less toward the outside so that you can show the texture of individual hairs.

3 Paint the Head and Chest
Paint the other side of the head with the same colors and techniques used in the previous step. Let it dry about 50 percent. Paint the chest the same way you painted the head. Leave white for highlights. Load the medium brush with dark ink and split its tip with your fingers to create the texture of individual hair on the head and chest.

4 Paint the Hip and Tail
Use the medium brush to paint the legs and hip with a light value of ink. Then add a dark value of ink to the brush and paint the strokes where the dog and ground meet. The darker ink "seats" the dog on the ground. Mix Vermilion with Carmine and a little ink to paint the back. Then pick up dark ink on the tip to paint the tail in a few strokes moving out from the body.

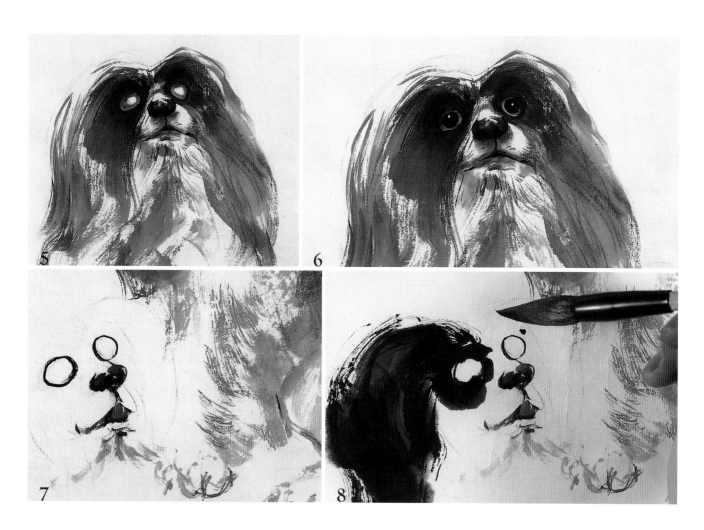

5 Apply Colors on the Face and Eyes
Use the small brush to paint Yellow on the eyeballs, below the nose and the chin. Paint Carmine on top of the eyeballs. Mix the Carmine and a little ink to paint the nose and upper lip area.

6 Add the Pupils
Use the small brush to paint the pupils with very dark ink. Leave a white spot as a highlight.

7 Paint the Second Dog
Start painting the dog on the left. Use the small brush to outline the eye, nose and mouth. While the ink is wet, apply midtone ink on the nose. Paint the tongue with Vermilion and Carmine.

8 Paint the Left Eye and Detail the Hair
Use the large brush to paint the hair around the left eye. Mix the Vermilion and Carmine with a little ink. Paint around the eye and the hair. Next load dark ink up to the middle of the brush to paint the texture of the hair. This figure shows the loaded brush ready to paint the right side of the head.

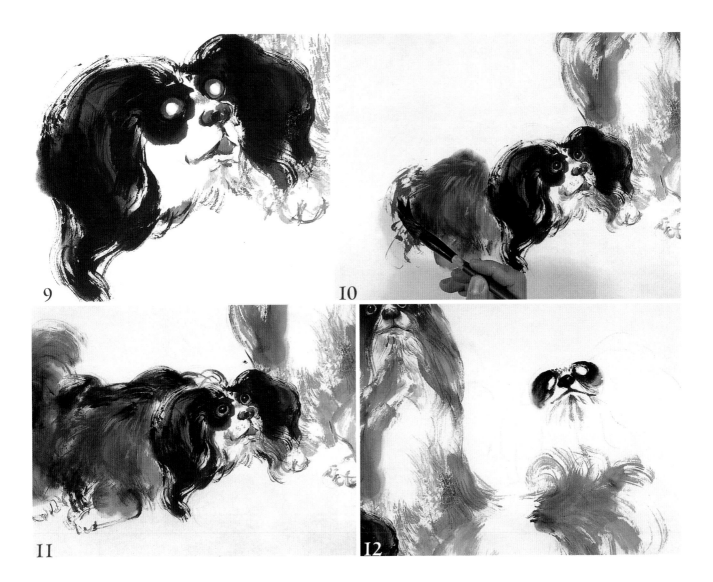

9 Finish the Head

Paint the right side of the head as you painted the left side. Dip your brush in a small amount of water and lay it on a dry paper towel to remove excess water to get a drybrush effect. Use the small brush to apply Yellow and Carmine on the eyeballs.

10 Paint the Pupils and the Body

Load the small brush with very dark ink and paint the pupils, leaving highlight spots. Use the large brush to mix Yellow and Vermilion to paint the body. While the colors are wet, paint the hair with a medium value of ink. Split the tip of the large brush and get thick Yellow to paint the lighter colors of the hair.

11 Finish the Second Dog

Use the large brush to mix Yellow, Vermilion and Carmine with ink to paint the tail. While the colors are damp, split the tip and pick up dark ink to paint the texture of the hairs on the tail and back. Use the medium brush to paint the legs.

12 Start Painting the Third Dog

The third dog is behind the first dog, which was painted with light colors. Therefore you want to paint the third dog with dark ink to make the first dog stand out. Load the medium brush with ink and paint the eyes, nose and the mouth, applying a light value of ink first and then a dark value of ink.

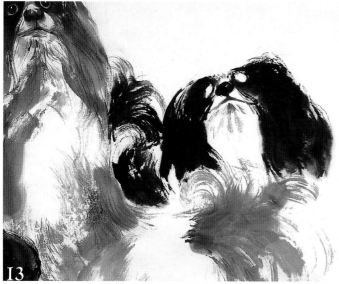

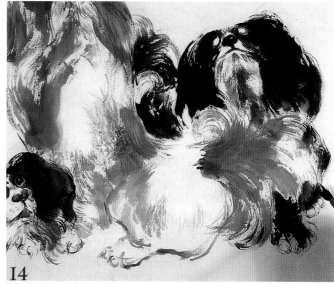

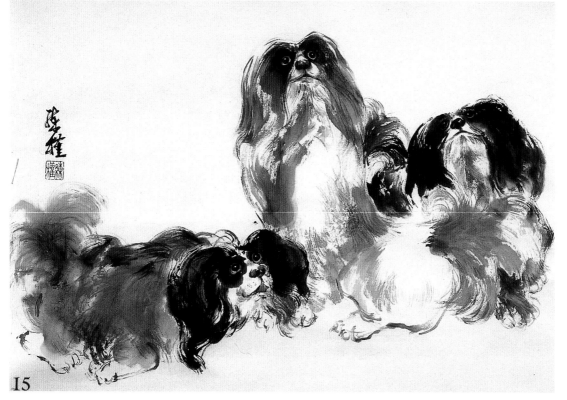

Dogs 18" × 26" (46cm × 66cm) *Chinese ink and colors on double-layer raw Shuan paper*

13 Paint the Head and Tail
Paint the head and the tail with the large brush loaded with ink. Apply light ink first then dark ink. Paint the strokes in the same direction that the hair is growing.

14 Create Legs and Hair
Leave whites to suggest the white hair of the first dog. Create the legs by splitting a medium brush and painting on the light ink strokes to get the hair effect.

15 Add Final Details
Paint the eyeballs of the third dog using the small brush loaded with Carmine and ink. Paint the pupils with very dark ink and leave some highlights.

DOG

In this demonstration you will learn how to integrate Chinese techniques into watercolor. You will paint this dog using many similar techniques from the last demonstration: using strokes to define the hair and legs and leaving a lot of white in the background and for the white hair.

🎇 MATERIALS

PAPER
140-lb. (300gsm) cold-pressed water-color paper, half sheet

BRUSHES
1-inch (25mm) and 1½-inch (38mm) flats • Nos. 2 and 4 rounds • Fan

WATERCOLORS
Cadmium Red Deep • Cadmium Yellow Light • Ultramarine Blue

OTHER
Soft charcoal

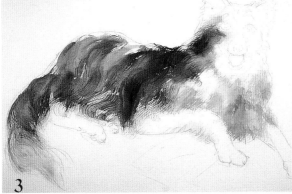
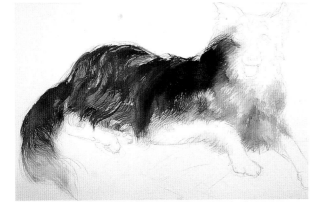

1 Sketch the Dog

Sketch one dog using the soft charcoal. Wet the body lightly with water. Using the fan brush instead of a flat brush to wet the paper helps create the texture of hair.

2 Add the Base Body Color

Use the 1½-inch (38mm) flat to apply Cadmium Yellow Light on the body. Immediately use the same brush to add a few stokes of Cadmium Red Deep. Do not overmix the colors on the painting—let them gracefully blend into each other. Use the fan brush to create the hair texture. Brush the colors according to the direction the hair is growing.

3 Create More Hair

When the colors are about 50 percent dry, use the fan brush to detail more hair. Mix Cadmium Red Deep and Cadmium Yellow Light to paint the orange hair. Mix Cadmium Red Deep and Ultramarine Blue with a little Cadmium Yellow Light to paint the brownish hair. For the darker color hairs use a dark mixture of Ultramarine Blue and Cadmium Red Deep with very little water.

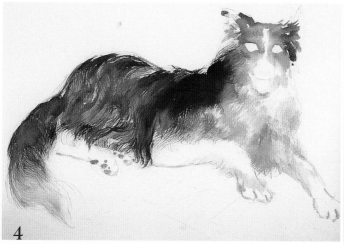

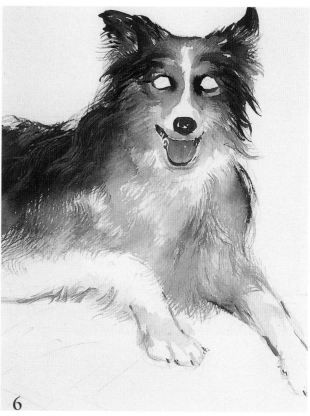

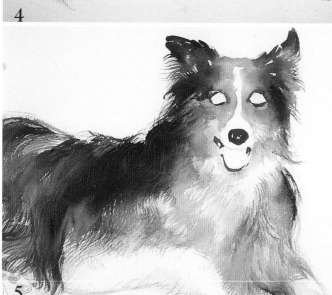

4 Paint the Face, Ears and Chest
Wet the face and forehead with water using a 1-inch (25mm) flat. Slightly mix the Cadmium Yellow Light and Cadmium Red Deep on your palette. Paint the face, ears and the chest, leaving white for the white hair. Add a little Ultramarine Blue to the color mixture to get a darker brown. Load that onto the fan brush and paint the right ear.

5 Add Facial Details
Define the ears, eyes, nose and mouth with more of the dark brown. Use the 1-inch (25mm) flat to paint larger areas and the no. 4 round to paint the smaller details.

6 Paint the Tongue and Neck
When the colors are almost dry, load the fan brush with a thick mixture of Cadmium Yellow Light and a little Cadmium Red Deep and paint the orange hair near the eyes and on the neck. Use the no. 4 round to paint the tongue with Cadmium Red Deep. When the tongue is about 50 percent dry, add a little Ultramarine Blue to the end of it.

DOG *Watercolor 11″ × 15″ (28cm × 38cm) 140-lb. (300gsm) cold-pressed watercolor paper*

7 Accent Hair

Use the no. 2 round to detail the hair on the head. Use a dark layer of Cadmium Red Deep on the lighter colored areas and a dark layer of Cadmium Yellow Light on the darker areas.

8 Create Eyes and Chin Hair

Paint more hair on the chin using the fan brush and a mixture of Cadmium Yellow Light and a little Cadmium Red Deep . Paint the eyeballs using the no. 2 brush loaded with Cadmium Yellow Light. Let the pigment dry about 50 percent and apply Cadmium Red Deep on the pupils. When both of the colors are almost dry, create a very dark purple mixture of Ultramarine Blue with a little Cadmium Red Deep and paint the pupils, leaving white spots as highlights.

9 Add Background

Use the 1½-inch (38mm) flat to paint the background with Ultramarine Blue and a little Cadmium Red Deep. Use a darker background color around the lower edges of the dog. While the colors are wet, splash on a few drops of Cadmium Yellow Light to coordinate the background colors with the rest of the dog.

CRAB

In this demonstration you will explore detail-style techniques. For detail style you have to use mature Shuan paper because it doesn't absorb water or allow the colors to bleed. You should paint on the sparkling side of the mature Shuan paper since the sparkles enrich the colors. Creating a detail-style painting is like meditating: If you take your time and follow the steps patiently you will get a nice painting.



🞧 MATERIALS

PAPER
10" × 14" (25cm × 36cm) mature Shuan paper

BRUSHES
Small and medium hard fur • Medium and large soft fur

CHINESE PAINTS
Burnt Sienna • Carmine • Indigo • Ink • Vermilion • White • Yellow

OTHER
Pencil • Tracing paper • Ink pen • Drafting tape • Paper towels

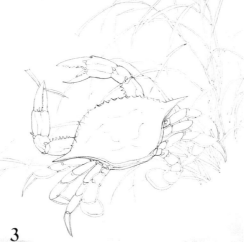

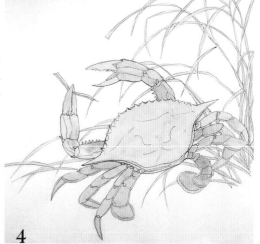

1 Sketch the Basic Composition
Sketch the composition of a crab in grass with a pencil on a 10" × 14" (25cm × 36cm) piece of tracing paper. Use an ink pen to draw the objects more carefully in detail on the tracing paper.

2 Transfer the Sketch
Lay the mature Shuan paper on top of the tracing paper. Use drafting tape to hold them together across the top. Lay both of the papers on your painting surface. Load the small brush with midtone ink. Trace the crab and grass on the mature Shuan paper. Your brush should not have a lot of water and ink, or it will be difficult to paint fine strokes.

3 Complete the Sketch
Here is the complete ink sketch on the mature Shuan paper. The brushstrokes are neither extremely wide, nor broken into many tiny segments.

4 Add the First Layer of Color
Use the two medium brushes for the first layer of color—one brush is for blending and one for applying colors. Use Indigo and Yellow for this layer. Wet the shell and apply a thin layer of Yellow on it. In the same way paint the other parts of the crab and grass first with Yellow and then with Indigo. If you see water bubbles on the Shuan paper, it means you have too much water. Blot your brush on a paper towel to soak up some of the water.

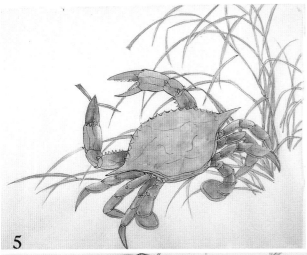

5

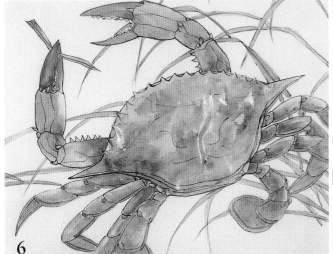

6

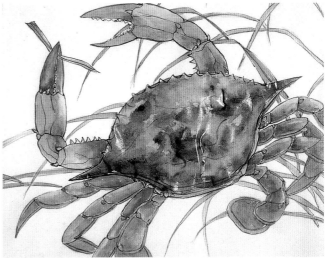

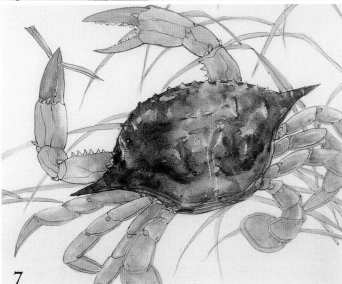

7

5 Paint the Second Layer of Colors
Let the first layer of color dry, then apply the second layer. Use the same colors and paint the second layer the same way you painted the first. Add Carmine around the claws and Vermilion on the tips of the grass.

6 Enhance the Shell
Let the second layer of color dry. Now apply more colors on the shell. To capture the texture of the shell, wet it with more water than usual to create water bubbles. Apply Indigo on the shell and immediately add some ink.

7 Layer More Colors on the Shell
While the colors on the shell are still wet, apply Burnt Sienna, using a medium brush. Next, paint the darker area of the shell with a mixture of Indigo and ink. You may realize that the way you are painting the shell is similar to painting watercolor because you apply the colors wet-in-wet, allowing the paints to blend into each other.

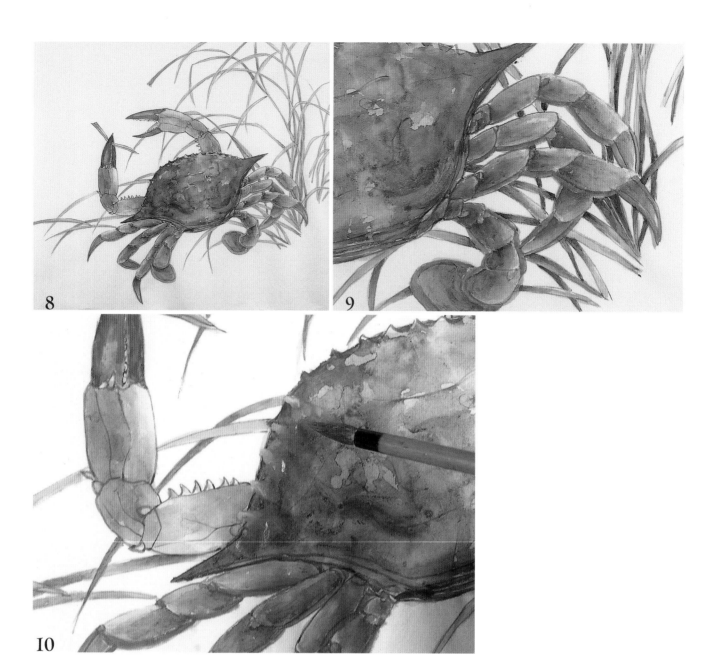

8 Tone the Claws, Legs and Grass

Use the small brush to accent the joints of the claws and legs with darker values. Then use the medium hard fur brush to blend the darker colors on the legs to form a gradation: darker at the joints and lighter the farther away from the joints the color goes. Grade the grass in a similar way.

9 Define Claws, Legs and Grass

After the colors dry, grade the claws, legs and grass one more time. For this layer, mix the base colors into a darker value with more ink. At the area where two or more objects meet, paint the one behind darker, this is called *dark against light* or *light against dark*, a very useful technique to define objects.

10 Paint the Pincers on the Shell

Load Yellow on the heel of a medium hard fur brush, add Burnt Sienna at the middle and White at tip. Hold the brush sideways with its tip pointing to the edge of the shell. Apply one stroke for each point. Immediately use the medium soft fur brush to blend the Yellow onto the shell with water.

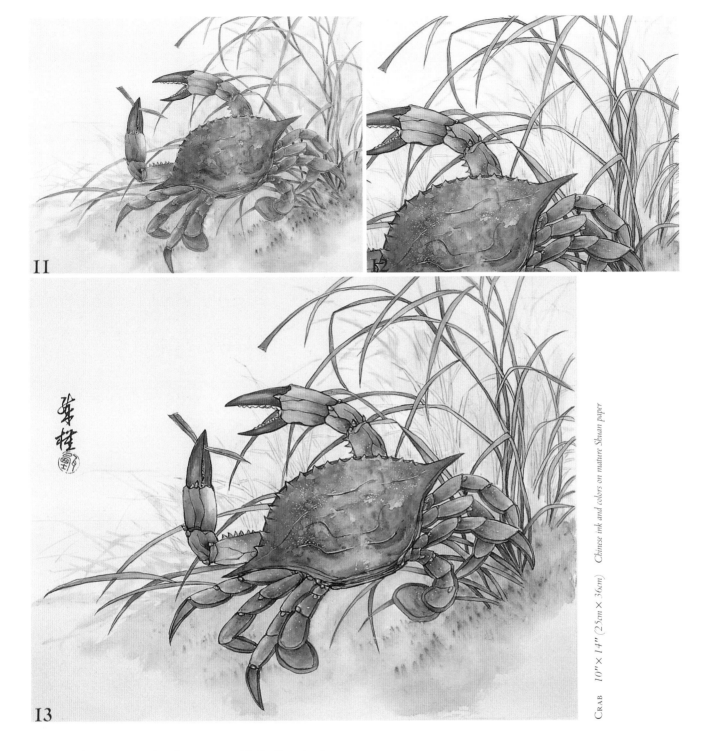

CRAB 10"×14" (25cm × 36cm) Chinese ink and colors on mature Shuan paper

11 Paint the Foreground and Background

Use the large brush to lightly wet the foreground and background. Use a medium hard fur brush to paint the grass with Yellow and Indigo. One stroke depicts one blade of grass. Mix Burnt Sienna and Indigo to paint short strokes as an illusion of dirt in the foreground.

12 Outline the Grass

After the background dries, use the small brush to outline some grass. There is a beautiful contrast between the outlined grass and the painted grass in the background.

13 Add Final Details

Use the small brush to apply a darker outline on all objects. The color for the second outline should be the objects' base colors plus ink. For example, the legs use Indigo and ink while at the pincers use Carmine and ink.

CRAB

This painting is fun to do. You will learn to splash colors on the shell to mimic its texture. You might have a problem using too much or too little color when you splash. Practice the splashing on another piece of paper to avoid this.

�֍ MATERIALS

PAPER
140-lb. (300gsm) cold-pressed water-color paper, half sheet

BRUSHES
½-inch (12mm) and ¾-inch (19mm) flats • No. 4 round

WATERCOLORS
Cadmium Red Deep • Cadmium Yellow Light • Ultramarine Blue

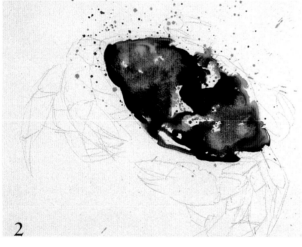

1 Paint the Crab Shell

Wet the shell, leaving some small dry areas as the highlights, using the ¾-inch (19mm) flat. Splash Cadmium Yellow Light on the shell. Blend the color into the wetted area. Lightly paint Cadmium Red Deep on the Cadmium Yellow Light. Since the Cadmium Yellow Light is wet, the Cadmium Red Deep blends gracefully with it on the paper. Some splashed colors are outside of the shell because they suggest movement.

2 Give the Shell Depth

Use the ½-inch (12mm) flat to splash Ultramarine Blue on the shell. Now you have blended three colors into each other. Mix a dark brown with Ultramarine Blue, Cadmium Red Deep and touch of Cadmium Yellow Light using the ¾-inch (19mm) flat. Do not mix the colors too much on the palette or you will get mud. Paint the edge and middle part of the shell. If the shell has too much water on it (notice the lower right corner of the shell), use a paper towel to blot the excess moisture.

3 Paint the Claws and Legs

Paint the claw on the right with a ½-inch (12mm) flat, using Cadmium Yellow Light, thinned with water to an ink-like consistency. While the color is wet, mix Cadmium Red Deep and Ultramarine Blue into a purplish color to paint the pincer and leave highlights there. Paint a dark brown mixture of Cadmium Red Deep and Ultramarine Blue with a little Cadmium Yellow Light on the claw. Paint the first leg with the same colors. Hold your brush sideways and paint one stroke for each joint. Paint the other legs with the same colors. Pick up more Cadmium Red Deep to paint the reddish portion and use more Cadmium Yellow Light for the yellow part. Paint the pincer of the upper claw with a light value in contrast with the dark colors that you will use for the legs underneath the pincer.

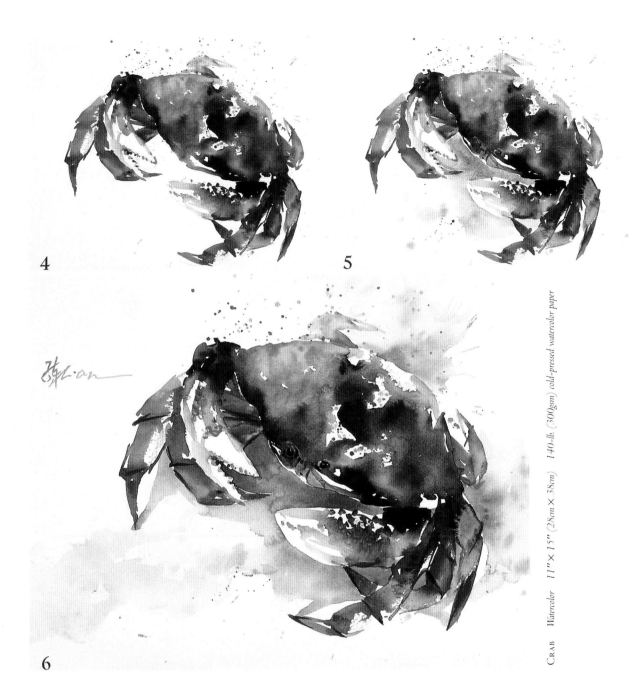

4

5

6

Watercolor 11" × 15" (28cm × 38cm) 140-lb. (300gsm) cold-pressed watercolor paper

CRAB

4 Create the Second Set of Legs

Paint the other set of legs with the ¾-inch (19mm) flat. Use medium-value colors that are lighter than the claw and the shell in the area between the beginning of the claw and the edge of the shell. Use a mixture of Cadmium Red Deep with a little Ultramarine Blue and Cadmium Yellow Light. This separates the objects and gives them depth.

5 Set the Background

Use the ¾-inch (19mm) flat to paint the background with a thin mixture of Ultramarine Blue and Cadmium Red Deep. Paint around the pincers to define their shape, as well as to suggest highlights. Leave white

on the body. Paint the eyes with a dark mixture of Ultramarine Blue and a touch of Cadmium Red Deep using the no. 4 round.

6 Add Final Details

Continue to paint the background with a mixture of Ultramarine Blue and Cadmium Red Deep using the ¾-inch (19mm) flat; then splash a few drops of Cadmium Yellow Light on it. Suggest some shadows on the legs. On the other side of the shell use the background colors to complete the shape. Wisp the colors out at upper right to create the impression of waterweeds.

ROOSTER, HEN AND CHICKS

In this spontaneous-style demonstration use the *No Bone* method: using no outline and painting just with colors and ink. When painting the large feathers on the tails of the rooster and the hen, paint one stroke for each feather. To successfully capture the texture of the chicks, it is important to control the amount of water in the brush. Paint fast but not carelessly. The more strokes you add, the more the colors will bleed, you don't want to end up with oversized chicks.

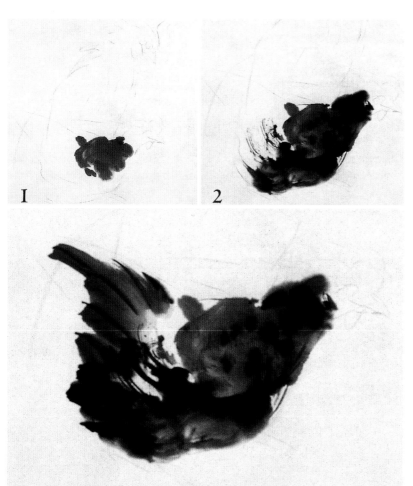

❀ MATERIALS

PAPER
14" × 20" (36cm × 51cm) raw Shuan paper

BRUSHES
Small hard fur • Medium and large soft fur

CHINESE PAINTS
Carmine •Indigo • Ink • Vermilion • Yellow

1 Sketch Composition and Paint the Feathers
Sketch a composition of a rooster, hen and three small chicks. Mix Vermilion, Carmine and ink into a brownish color with the large brush. Paint the neck of the hen with several strokes. Note: When you overlap strokes they create watermarks that give the impression of feathers.

2 Define the Feathers
Now the colors in your brush are almost all used. Wet the brush with a little water and load it with dark ink. While the color on the neck is wet, define the upper neck and paint the chest, wing and patterns of the feathers.

3 Paint the Tail Feathers
Rinse most of the ink from the large brush. Use it to mix the Vermilion and Carmine into a brown color. Paint the tail feathers by making several strokes from the body toward the upper left corner. While the tail is wet, load the medium brush with dark ink and paint one stroke on each feather.

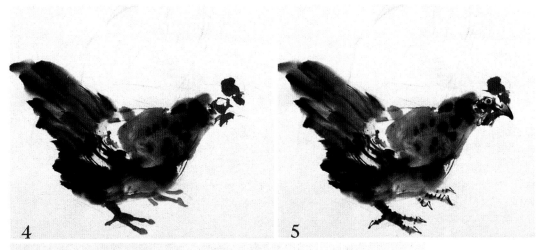

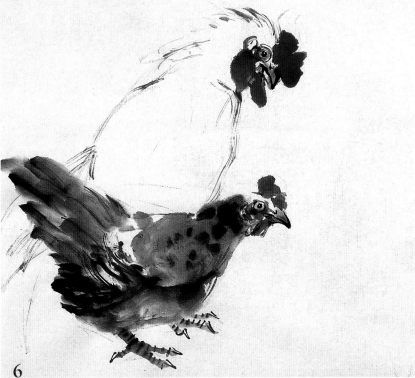

4 Paint the Toes, Face and Comb
Paint the feet with the brown color using
the medium brush. Each stroke represents
one toe. Load the brush with Vermilion and
a little Carmine to paint the face and comb.
Paint as few strokes as possible.

5 Finish Painting the Hen
Outline the eye and beak with dark ink using
the small brush. Add detail to the feet when
they are about halfway dry. Paint the eyeball
and the beak with Yellow and Vermilion.
Create the pupil with very dark ink, leaving
a small white spot as a highlight.

6 Begin the Rooster
Create a mixture of Vermilion and Carmine
to paint the comb and face using the large
brush. Use the small brush to outline the
eye and the beak with dark ink. Add Yellow
and Vermilion on the eyeball and the beak.
Outline the head, body and tail with a
variety of ink tones using the medium brush.

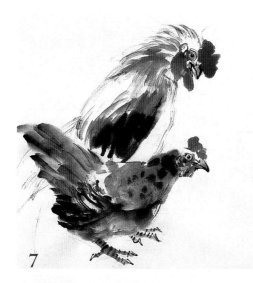

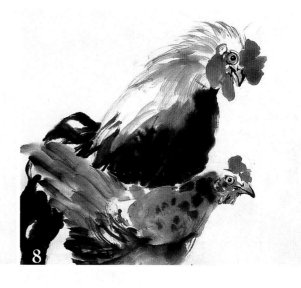

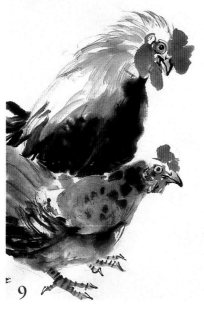

7 Paint the Neck, Back and Wing Feathers

Mix Yellow, Vermilion and a little Carmine with the medium brush to paint the neck and back feathers. Load the large brush with Indigo first and ink second. Your brush should have ink at the tip, dark blue in the middle and lighter blue at the heel. Hold the brush sideways to paint the wing feathers.

8 Paint the Chest and Tail Feathers

Continue using the large brush to paint the chest and tail feathers. Apply one brushstroke for each feather. Do not paint the feathers parallel to each other—overlapping them creates more interest.

9 Begin the Chicks

Load the medium brush with Yellow, add Vermilion up to its middle, and mix in a little Carmine with light ink at the tip. Hold your brush sideways with the tip toward the beak to paint the head in one brush stroke. Immediately paint the body with the tip pointing to the neck. Leave white for highlights on the top of the body.

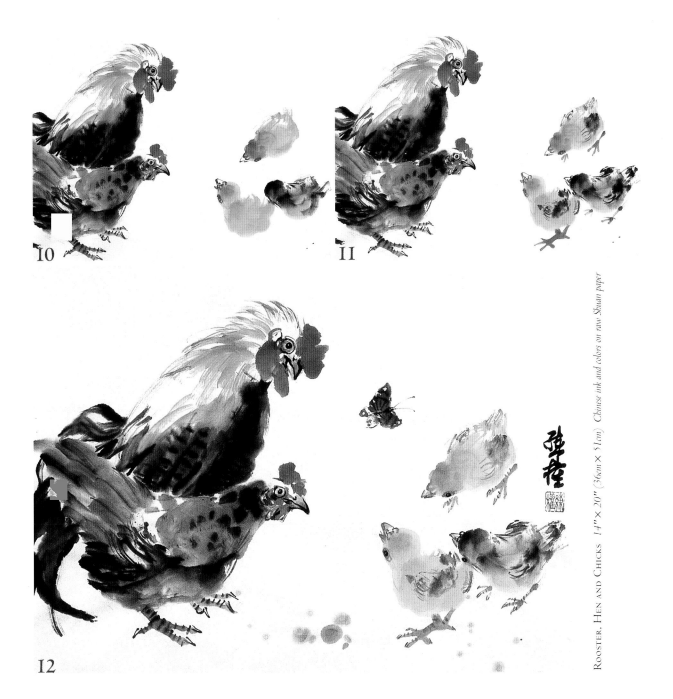

ROOSTER, HEN AND CHICKS 14" x 20" (36cm x 51cm) Chinese ink and colors on raw Shuan paper

10 Add the Other Chicks

When you finish one chick you have most likely you used up all the color in your brush. You don't need to wash the brush, just dip it in a small amount of water. Then pick up the same colors to paint the other chicks. For the darker-color chick use more ink. While the colors on their heads are wet, use the small brush to mix Vermilion and Carmine to paint their eye sockets. Mix the same colors with a little ink to paint their beaks and nostrils.

11 Accent the Wings and Tails

Paint the legs using the same small brush and colors. Use the medium brush to mix Vermilion, Carmine and ink. Paint a few strokes to emphasize the wings and tails.

12 Add More Details and a Butterfly

Use the small brush to paint the pupils with dark ink. To suggest the ground, use the medium brush to paint some light ink dots. Paint a butterfly to add more excitement to this painting. Mix ink with Indigo and hold the small brush sideways to paint the wings. While the colors are wet, use the same brush to pick up dark ink to paint the body and two antennae. Finally, use the small brush to pick up dark Yellow to paint the spots on the wings.

ROOSTER WITH CHICKENS

In this demonstration you will use a method I call *Half Color Pouring and Blending*. You don't start with pouring colors like when you painted the Egrets (page 78). Instead, paint the rooster first, then pour colors around it on the rest of the paper to create the background and foreground.

✴ MATERIALS

PAPER
140-lb. (300gsm) cold-pressed water-color paper, half sheet

BRUSHES
½-inch (12mm), ¾-inch (19mm) and 1-inch (25mm) flats • Nos. 2, 4 and 8 rounds

WATERCOLORS
Antwerp Blue • Cadmium Red Deep • Cadmium Yellow Light

OTHER
Pencil • Masking fluid • Three small dishes (to hold the three midtone primary color liquids) • Tracing paper • Paper towels • Spray bottle

1 Sketch the Composition and Mask Out the Hen, Chicks and Grass
Sketch the composition in pencil on tracing paper; once you've found a good composition (see page 30), transfer it to your watercolor paper. Mask out the hen, chicks and grass using a no. 8 round . Use the handle of the ½-inch (12mm) flat for the small details and the grass.

2 Start Painting the Rooster
Wet the head of the rooster with a ¾-inch (19mm) flat, leaving scattered dry spots on the top for highlights. Apply Cadmium Yellow Light on the comb, wattle and around the eye.

3 Apply Red
Use the ¾-inch (19mm) flat to apply thick Cadmium Red Deep on the Cadmium Yellow Light and let the colors freely mix into each other to get different blending effects.

4 Add Depth to the Head
Load the same brush with more Cadmium Red Deep and mix it with a little Antwerp Blue at the tip to obtain the dark red color. Apply this color to the top of the comb, around the eye and below the lower beak, to add depth.

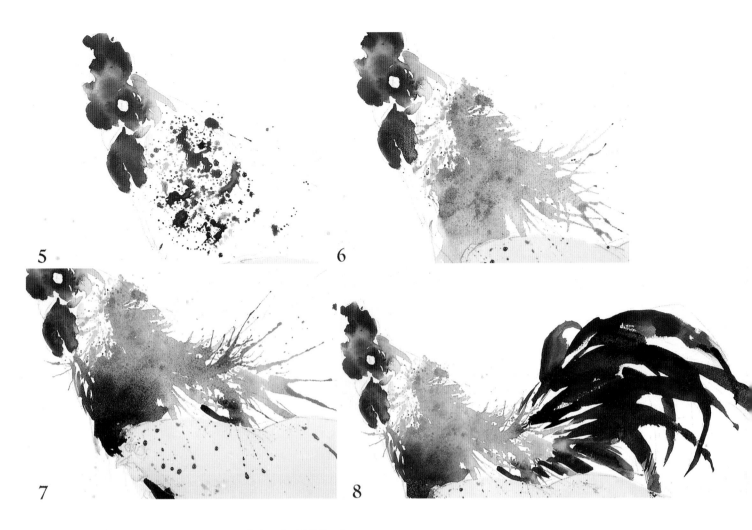

5

6

7

8

5 Paint the Neck
Using the 1-inch (25mm) flat, splash Cadmium Yellow Light, Cadmium Red Deep and Antwerp Blue on the neck. If some of your colors end up outside the neck, remove them with paper towel or a regular towel.

6 Create Feathers on the Neck
Blow the color splashes with your mouth to create the feathered texture on the neck. When you blow, position your mouth about one inch (25mm) from the colors and blow fast toward the rooster's body.

7 Paint the Neck and Chest
Create a dark mixture of Antwerp Blue and a little Cadmium Red Deep and paint the left side of the neck, chest and wing using the 1-inch (25mm) flat. Splash and blow Cadmium Yellow Light, Cadmium Red Deep and Antwerp Blue on the upper body. Use a paper towel to clean up any colors blown outside the rooster's body.

8 Paint the Tail Feathers
Create a dark mixture of Antwerp Blue with a little Cadmium Red Deep at the tip of the 1-inch (25mm) flat and paint the tail. Your brush has colors that range from dark blue at the tip to lighter and lighter blue toward the middle and heel. Paint one stroke for each tail feather. Load more Cadmium Red Deep onto the brush to paint the two red feathers. The key is to not overmix the colors on the palette, simply mix them in the brush. This prevents your colors from turning to mud.

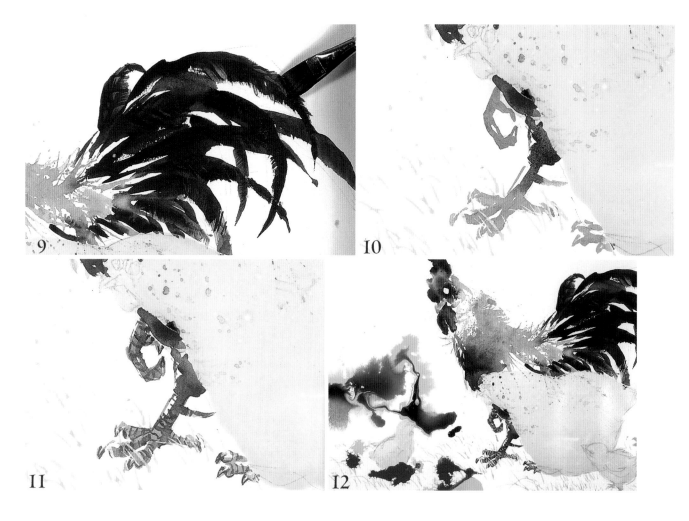

9 Add Texture to the Tail Feathers

Use the ½-inch (12mm) flat to paint the texture of the tail feathers. Lightly wet the brush then load it with a dark mixture of Antwerp Blue and Cadmium Red Deep. Split its tip by dabbing the brush onto a paper towel. Paint the textures on each feather from the center to the edges.

10 Paint the Legs

Mix Cadmium Yellow Light, Cadmium Red Deep and a little Antwerp Blue into a light brownish color using the no. 8 round. Paint the two legs with a few strokes. For example, each toe is one brushstroke. Slightly touch the dark blue color on the front thigh to blend it into the leg.

11 Detail the Legs

When the color on the legs is almost dry, use the no. 4 round to add details to them. Apply a darker blue mixture of Antwerp Blue and a little Cadmium Red Deep for the claws to suggest their hard and sharp character.

12 Pour the Foreground and Background

Paint the foreground and background with the *Color Pouring and Blending* technique (see page 70). First work on the left half of the foreground and background. Use a spray bottle of water to wet most of the area. Use the 1-inch (25mm) flat to wet the area around the chickens so the water does not touch the animals. Pour Cadmium Yellow Light and Antwerp Blue on the upper area where there is grass. Pour Cadmium Yellow Light and Cadmium Red Deep on the bottom where there is dirt and a little vegetation.

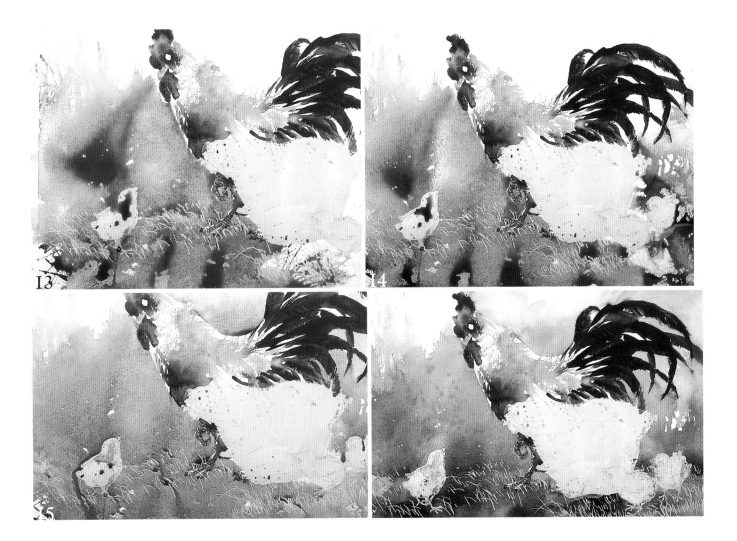

13 Define Animal Shapes

Spray the colors with the spray bottle to make them blend into each other more. Use the 1-inch (25mm) flat to direct the colors to the area next to the chickens. Use the colors to define the shapes of the animals. At the upper and lower left corners, blow the mixed colors to create the illusion of grass.

14 Add More Colors

Wet the right side of the foreground and background the same way as the left side. Pour Cadmium Yellow Light and Cadmium Red Deep on the bottom and Antwerp Blue and Cadmium Yellow Light on the middle.

15 Move Colors Around the Painting

Use the 1-inch (25mm) flat to drag the colors to the upper middle. This defines the back of the rooster. Also fill in the areas between the tail feathers. Tilt your painting down, directing the colors to flow toward you. This allows the colors to mix a little more, while the excess liquid flows off your painting.

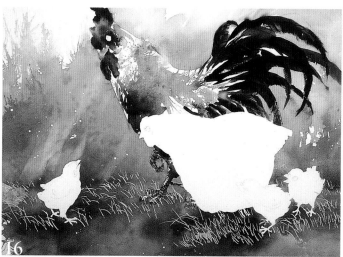

16 Create Light Rays and Remove Masking Fluid

Create a light ray effect on the left side of the background. Wet the 1-inch (25mm) flat with water and brush the background from upper right to lower left. This washes out the colors and the brushed areas become light rays. After the colors dry, remove the masking fluid from the hen and chicks.

17 Paint the Hen Head

Use the nos. 2 and 4 rounds to paint the hen's head much like you painted the rooster's in steps 2-4. Next use the 1-inch (25mm) flat to wet the hen and the front chick, leaving dry areas on upper parts of their bodies.

18 Create the Hen and Chick Bodies

Use the 1-inch (25mm) flat to apply Cadmium Yellow Light on the wet areas of the hen and the chick. Let the color blend out gracefully by itself. Immediately use the same brush to add a little Cadmium Red Deep and Antwerp Blue for the wings, tails and the volume of the bodies.

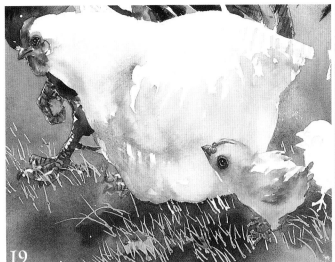

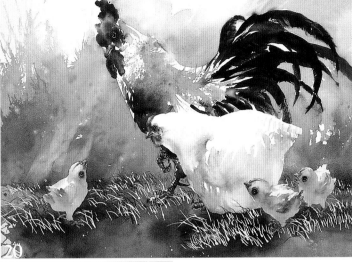

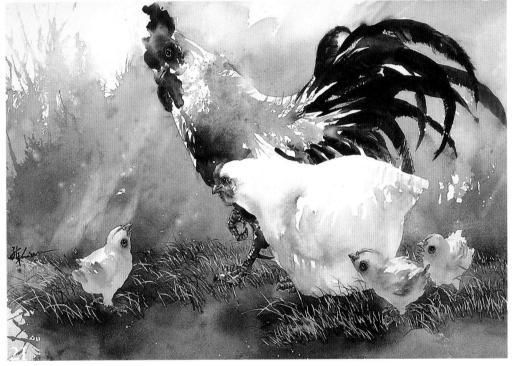

Rooster With Chickens *Watercolor 11" × 15" (28cm × 38cm) 140-lb.
(300gsm) cold-pressed watercolor paper*

19 Detail the Hen and Chick

Mix the Cadmium Red Deep and Antwerp Blue with the no. 4 round to paint the nostril, beak, little comb and the area around the eye of the chick. Also use the same colors to add a few strokes to bring out its wing and tail. Paint the hen and chick's eyes with the no. 2 round. Apply Cadmium Yellow Light for the eyeballs after the area around the eye is dry. Then add a little Cadmium Red Deep on upper part of the eyeballs. Wait until the colors are almost dry and create a dark mixture of Antwerp Blue with little Cadmium Red Deep; paint the pupils, leaving little white spots as highlights.

20 Finish Chicks, Remove Masking from Grass

Paint the other two chicks the same way as you painted the chick in the front. When the colors are dry on all three chicks and the hen, lift the masking fluid from the grass.

21 Add Final Details

Paint Cadmium Yellow Light on the grass using the no.4 round; apply Antwerp Blue on the lower part. Sign your name in the lower left corner to balance the composition.

CAT

From this detail-style demonstration you will learn to paint animal hair. Unlike spontaneous style—where you paint fast and apply a minimum number of strokes— in detail style you paint slowly and apply many layers of colors. The mature Shuan paper is made for taking layers of colors without letting the colors become muddy. Even if you paint up to nine layers of color, the painting still looks spectacular.

✿ MATERIALS

PAPER
12" × 16" (30cm × 41cm) mature Shuan paper

BRUSHES
Small hard fur • Medium and large soft fur

CHINESE PAINTS
Carmine • Indigo • Ink • White • Yellow

OTHER
Pencil • Tracing paper • Ink Pen • Drafting Tape • Paper towels

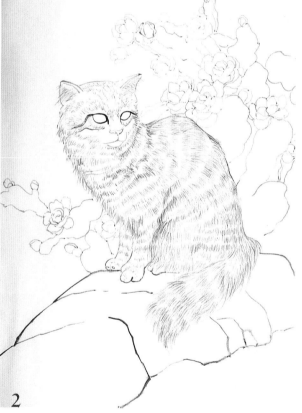

1 Trace Composition
Use a pencil to sketch the composition on a 12" × 16" (30cm × 41cm) piece of tracing paper. Then use an ink pen to outline the objects, making them darker. The darker outlines allow you to see the composition through the mature Shuan paper, when you create the first outline in the next step.

2 Transfer the Composition
Lay the mature Shuan paper on top of the tracing paper and secure them with drafting tape on one edge. Wet the small brush a little and dilute the ink to create a midtone. Before applying strokes, dab the small brush on a paper towel to blot excess water and ink. Carefully outline the images starting from the cat's head. For the eyes, paws and rocks use darker ink.

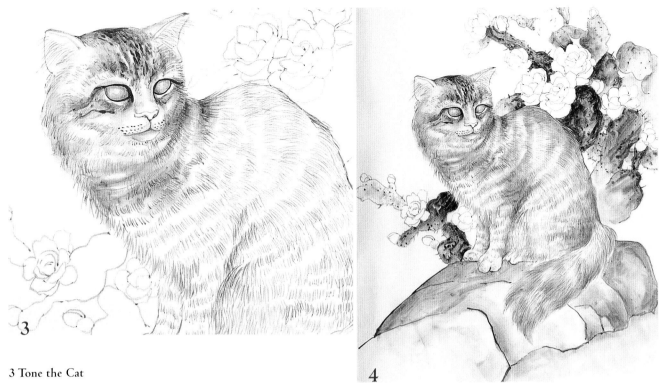

3 Tone the Cat

Use two brushes to tone the objects with ink: the medium brush for blending and the small brush for applying ink. First lightly wet the area you want to tone; If you get water bubbles, you have used too much water. Apply ink to the wet area. This process is like toning in a pencil sketch.

4 Capture the Cat's Spirit

Add more details to the head with a larger variety of ink tones than to the other parts of the animal because the head is important in capturing the cat's spirit.

Toning Methods for Detail-Style Paintings

METHOD 1: WET-ON-DRY

1. Use one brush to apply ink.
2. Dip another brush in a little water. Touch the middle of the stroke and blend it toward the right. Do not start from the left edge of the stroke or you get even blending without the gradient effect
3. Continue using the wetted brush to blend the ink toward the right side more to get the gradient from dark ink to white.

METHOD 2: WET-IN-WET

1. Wet the toning area. Pick up ink with another brush and dab it in the wetted area.
2. Start pushing the ink with the brush you used for wetting the paper from the edges of the center out to both sides.
3. Drag the ink farther from the right edge of the stroke toward the right; from the left side edge of the stroke toward the left to create the gradient effect. Do not drag the ink from the center or you get even ink tone without the gradient effect.

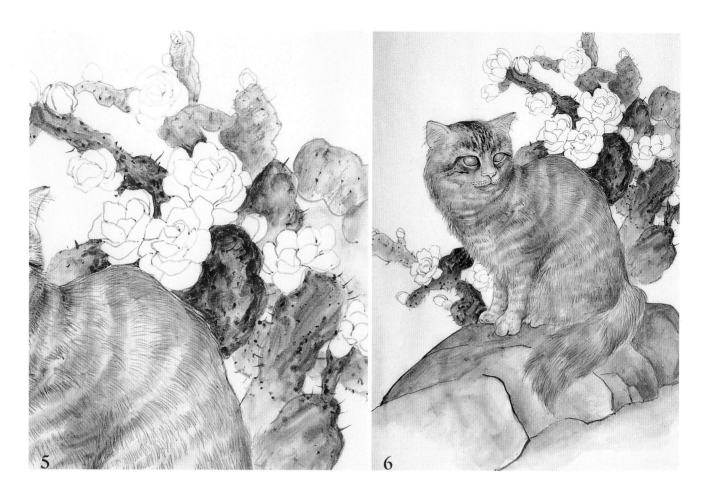

5 Form the Cacti

Wet the cacti with a medium brush until you start to get bubbles; then add dark ink. It blends into the water creating a nice texture. When the ink is about 70 percent dry, paint the needles with the small brush and dark ink. The dark ink of the needles slightly blends into the lighter ink of the cacti suggesting that they are attached.

6 Lay in the First Layer of Color

After the ink dries use the medium brush to apply Yellow on the cactus bodies, Carmine on the cat and Indigo on the rocks. It is important not to apply a thick layer of color at the beginning because detail-style paintings need multiple layers of color— sometimes up to nine layers—to achieve their beautiful effect. This is much different from watercolor, as well as spontaneous style in Chinese painting.

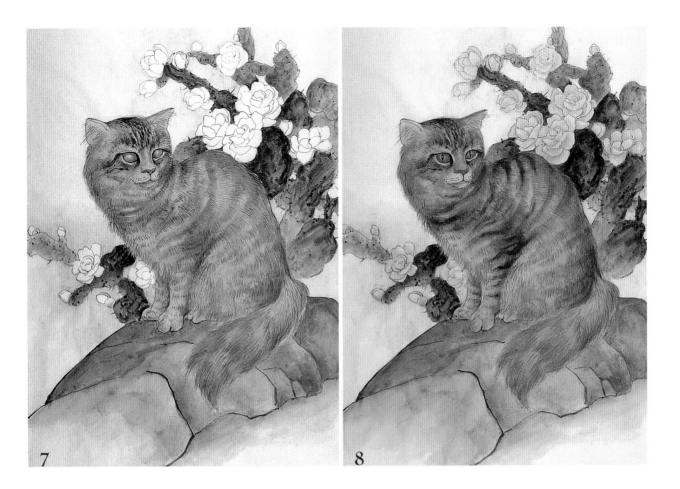

7 Add the Second-Layer Colors

After the first layer colors dry, apply a second layer of colors. Paint a thin layer of Yellow where the cat meets the rocks. Apply a thin layer of Indigo on the cacti and around the flowers. Painting the background around the flowers causes them to stand out.

8 Add More Color and Tones

Let the second layer of colors dry, then apply a third layer. Paint Carmine on the body of the cat. Paint its eyes with Yellow and Carmine, adding dark ink to the pupils, leaving white spots as highlights. Add Carmine to its nose.

Next, add one thin layer of Carmine on the rock with the large brush. Paint a thin layer of Yellow for the flower. Use the small and medium brushes to tone the petals with Carmine at the beginning and Yellow from the middle to the tip. Tone a few petals each time to gracefully blend the colors.

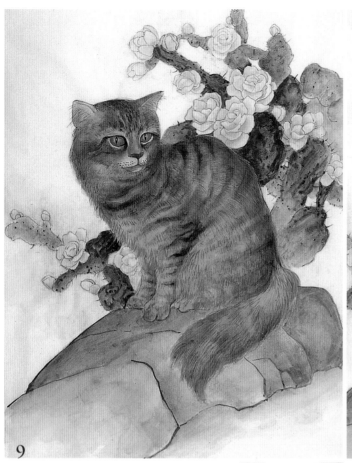

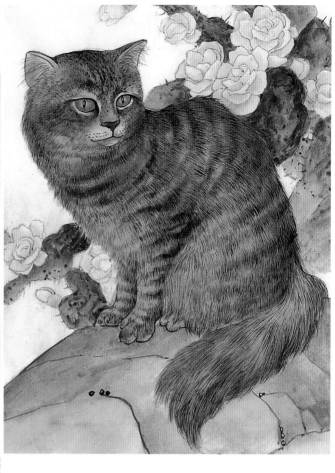

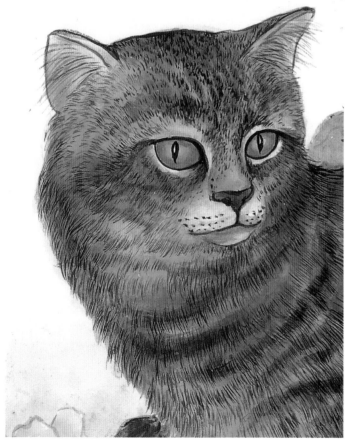

9 Add More Color and Detail

Apply the last layer of Carmine on the cat to finish his color. When the Carmine is dry, use the small brush to detail the individual hairs. For dark-colored areas such as the stripes, use dark ink. On the light areas, such as the spaces between the stripes, use Carmine mixed with a little ink. Paint more details for the head.

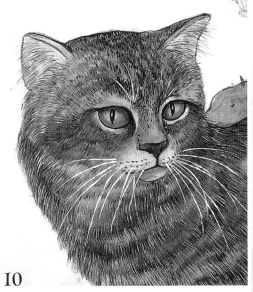

10

10 Highlight the Hair
Load the tip of the small brush with White. Paint one stroke for each whisker and hair on the head and body. Mix the White with a little Carmine to paint the pinkish colored hair. Let dry.

11 Add the Final Outline
You are creating this outline because the original outline is covered by multiple layers of color. The second outline is darker than the first one. Use a dark value of Carmine (mix Carmine with ink) for outlining the cat and dark value of Indigo (mix Indigo with ink) for the cacti.

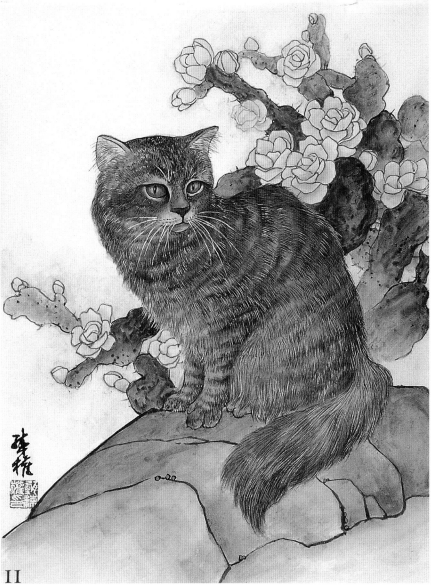

11

CAT *12" × 16" (30cm × 41cm) Chinese ink and colors on mature Shuan paper*

CATS

This demonstration uses the *Half Color Pouring and Blending* technique. You will paint the cats first and then pour on the three primary colors to create the foreground and background. Strong value contrast also plays a big role in defining the front cat.

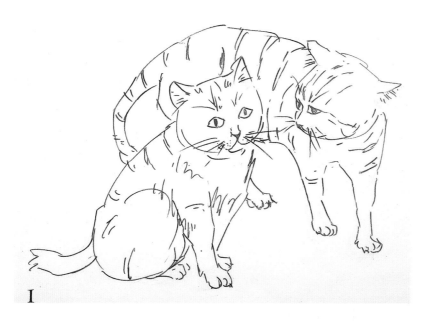

1

✿ MATERIALS

PAPER
140-lb. (300gsm) cold-pressed water-color paper, half sheet

BRUSHES
½-inch (12mm), 1-inch (25mm) and 1½-inch (38mm) flats • No. 2 round • Fan

WATERCOLORS
Antwerp Blue • Cadmium Red Deep • Cadmium Yellow Light

OTHER
Pencil • Tracing paper • Art masking fluid • Three small dishes (containing the three midtone color liquids)• Paper towels

1 Sketch Two Cats and Transfer the Sketch to Watercolor Paper

Sketch two cats in pencil on a piece of tracing paper that is the same size as the watercolor paper. Lay the tracing paper on a light box and lay your watercolor paper over it. Transfer the image to your water-color paper with pencil. If you don't have a lightbox, tape the tracing paper on a window then tape the watercolor paper on top of it and trace the objects with pencil.

2 Mask the Whiskers and Paint the Head

Use the handle of the ½-inch (12mm) flat to apply masking fluid to the whiskers and long white hairs on the eyes and ears. After the masking fluid dries, start painting the head of the first cat. Use the 1-inch (25mm) flat to wet the head lightly and apply Cadmium Yellow Light on it.

2

3

3 Layer the Colors

Use the same brush to apply a layer of Cadmium Red Deep on top of the Cad-mium Yellow Light. Let the colors blend by themselves; don't overmix them with your brush. Use the no. 2 round to paint the nose with Cadmium Red Deep.

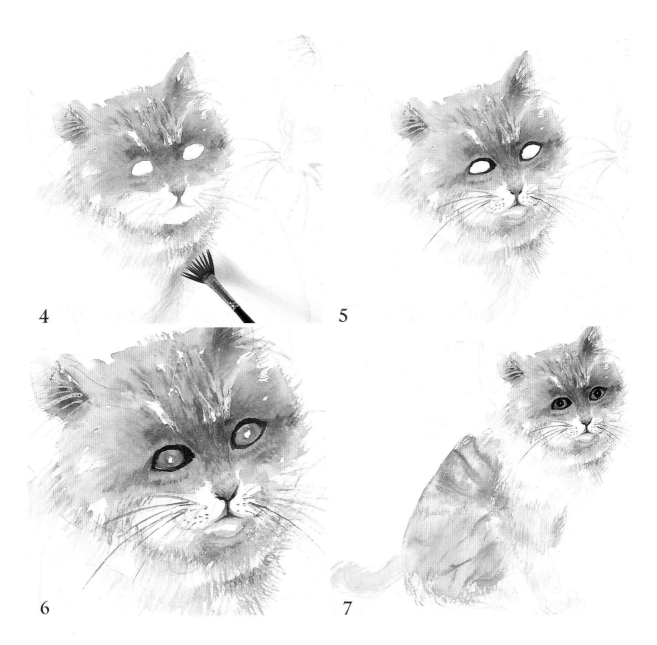

4

5

6

7

4 Detail Hair on the Face

While the colors are still wet, drag a fan brush across them to create the texture of hair. Create a mixture of Cadmium Red Deep with a little Antwerp Blue and paint the hair on the areas around the eyes and forehead.

5 Paint the Face

Slightly wet the no. 2 round and load it with Antwerp Blue and a little Cadmium Red Deep. Mix the two colors on the palette into very dark purple. Paint the area around the eyes, bottom of the nose and the mouth. Make the dark purple color lighter by dabbing the brush on a paper towel, then paint the whiskers.

6 Paint the Eyes

Paint Cadmium Yellow Light on the eyeballs using a no. 2 round. Immediately add Cadmium Red Deep in the center, leaving white spots for highlights. Let these two colors gracefully blend into each other on the paper.

7 Add Pupils and Detail More Hair

When the colors on the eyeballs are almost dry, use the no. 2 round to paint the pupils with a dark mixture of Antwerp Blue and Cadmium Red Deep, leaving white spots as highlights. Next wet the body with the 1½-inch (38mm) flat and apply Cadmium Yellow Light and Cadmium Red Deep on the wet areas. While the colors are wet, drag a fan brush across them to create the detail of individual hairs.

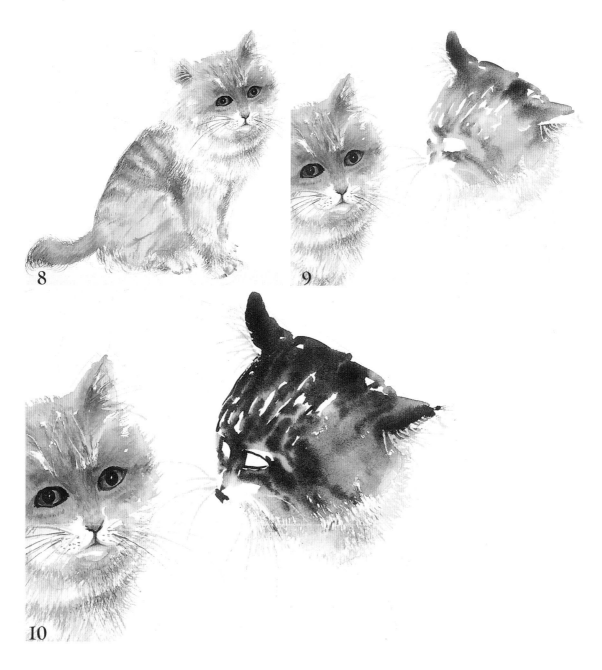

8 Add Darker Hair

Continue painting more hair with the fan brush. For the darker-colored hair, mix Cadmium Red Deep with a little Antwerp Blue and paint the hair in the direction it grows.

9 Start Painting the Second Cat

Wet the head of the second cat with the 1-inch (25mm) flat. Leave dry areas for the white hair and highlights. Immediately use the same brush to apply Cadmium Yellow Light and then Cadmium Red Deep on the wet areas to define the patterns and shape.

10 Detail the Hair

Use the ½-inch (12mm) flat to create a dark blue mixture of Antwerp Blue with a little Cadmium Red Deep. Paint the dark hair on the head and ears. Leave some white for the white hair. Drag the fan brush over the colors to paint the hair in the direction it grows.

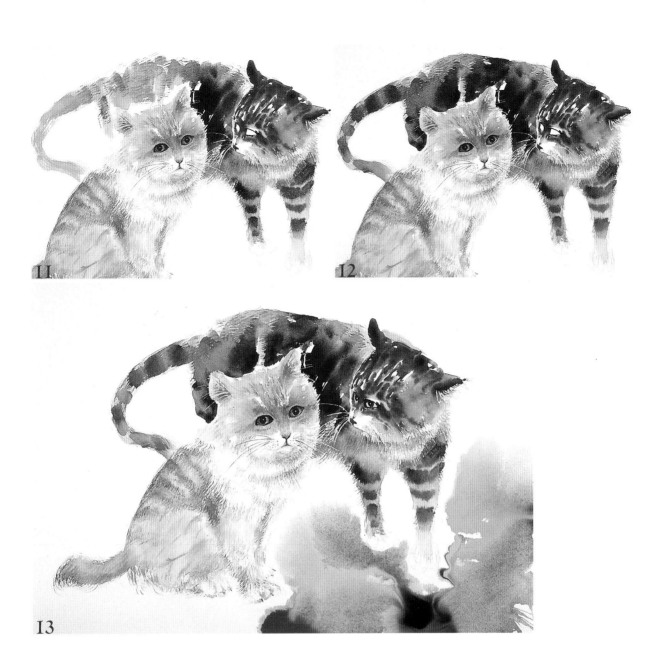

11 Paint the Body

Wet the body, tail and legs of the second cat using the 1½-inch (38mm) flat. Avoid touching the front cat because you do not want color to go there yet. Use the 1-inch (25mm) flat to apply Cadmium Yellow Light and Cadmium Red Deep on the wet areas. While the colors are wet, use the 1-inch (25mm) flat to create a dark blue mixture of Antwerp Blue and a little Cadmium Red Deep. Drag the fan brush across the colors to detail the dark hair.

12 Use Light Against Dark

Paint dark blue hair on the tail and on the areas of the body that border the front cat, using the ½-inch (12mm) flat. Apply a darker color behind the front cat to make its head stand out more. This technique is called *light against dark*, and it is very useful in defining overlapping objects.

13 Paint the Background and Foreground

Start painting the background and foreground using the *Color Pouring and Blending* technique (see page 70). Wet the lower right side of the background with the 1½-inch (38mm) flat. Do not let the water spill onto the cats. Pour the Cadmium Yellow Light, Cadmium Red Deep and Antwerp Blue in the lower right.

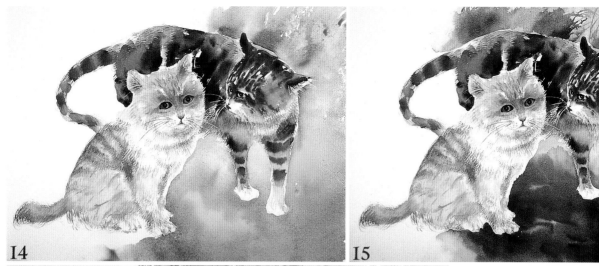

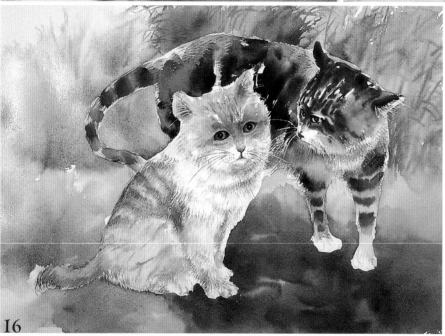

14 Direct the Colors
Use the 1½-inch (38mm) flat to direct the colors into the areas surrounding the cats. Blow the colors into the lower right corner to create the illusion of grass.

15 Create Grass and Shadows
While the colors are wet, use the no. 2 round to paint the background grass. Mix Antwerp Blue with a little Cadmium Red Deep and paint rapidly. Apply one stroke for each blade of grass. Use the 1-inch (25mm) flat to mix the Antwerp Blue with a little Cadmium Red Deep and paint the dark blue color on the foreground to make shadows.

16 Start Painting the Left Side
Wet and paint the left side of the background and foreground the same way as you painted the right side. Apply lighter values and put minimum details on this side from how you painted the right.

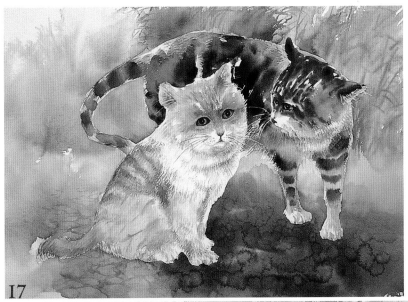

17

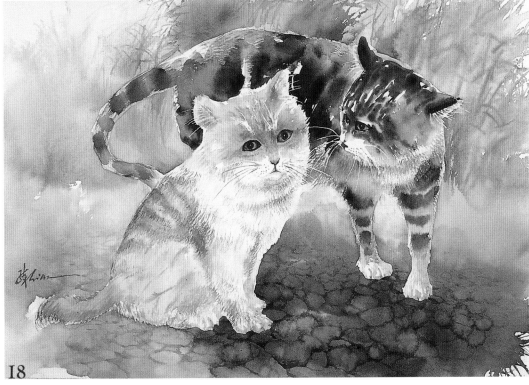

18

CATS Watercolor 11" × 15" (28cm × 38cm) 140-lb. (300gsm) cold-pressed watercolor paper

17 Add Texture to the Rocks

Let the ground dry about 70 percent, then use the 1-inch (25mm) flat to splash water on the ground. Each drop of water washes away the colors creating lighter spots.

18 Add the Final Details

Use the no. 2 round to mix the Antwerp Blue and Cadmium Red Deep into dark purple. Apply the color at the edge of each spot to define the rocks. After all the colors on the painting dry, lift up the masking fluid for the whiskers and hair.

STRETCHING A CHINESE PAINTING

After you finish a painting on a piece of Shuan paper, the paper will warp. To display the painting nicely, you should stretch it. It is not a difficult process if you follow these steps.

Stretching a Chinese painting is similar to pasting wallpaper. Shuan papers are fragile, especially the raw Shuan paper. During the stretching process the paper is saturated and weakened more so it's a good idea to practice the stretching process with discarded paintings or small paintings, until you are confident with the technique. Then you can confidently stretch the paintings you want to keep.

✿ MATERIALS

pH neutral pure wheat starch (you can buy it from art supply stores) • 4- or 5-inch (102mm, 127mm) flat soft fur brush • Spray bottle • Double-layer raw Shuan paper, 2 inches (51mm) larger than the painting • Large plate about twice the size of the brush • Roll of paper towels • Plexiglas (or other smooth surface for stretching) • Plywood board or a wall bigger than your painting (for drying the painting)

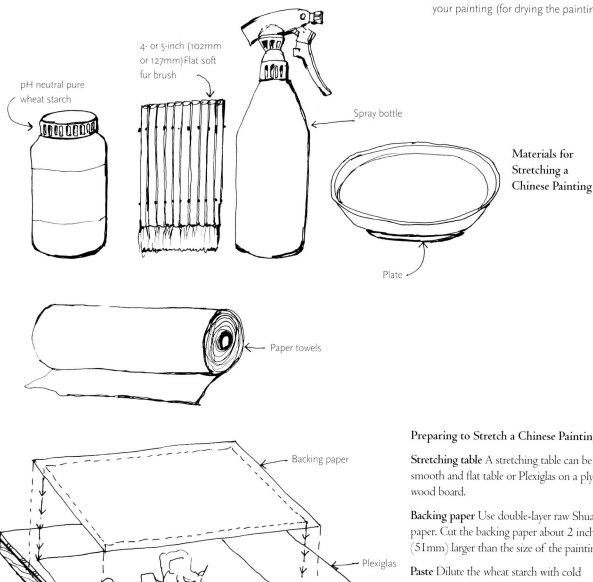

pH neutral pure wheat starch

4- or 5-inch (102mm or 127mm) Flat soft fur brush

Spray bottle

Plate

Materials for Stretching a Chinese Painting

Paper towels

Backing paper

Plexiglas

Plywood

Painting

Preparing to Stretch a Chinese Painting

Stretching table A stretching table can be a smooth and flat table or Plexiglas on a plywood board.

Backing paper Use double-layer raw Shuan paper. Cut the backing paper about 2 inches (51mm) larger than the size of the painting.

Paste Dilute the wheat starch with cold water in a 1:10 ratio. Put the liquid on a stove and stir it slowly while cooking. It is like cooking gravy. As you boil it, the texture of this "gravy" is like clam chowder.

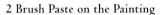

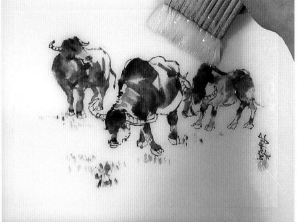

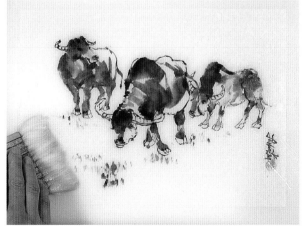

1 Place Your Painting on the Plexiglas

Take your painting, flip it over and line it up on a corner of the Plexiglas. Place it about 2 inches (51mm) away from the two edges of the Plexiglas. Spray water on the painting. Roll up your backing paper and put it aside near the painting.

2 Brush Paste on the Painting

Once the painting is wet it stretches a little. Pick up the starch paste with the flat brush and brush it on the back of the painting. Always brush from the center toward the edges. It is like putting paste on wallpaper. Keep brushing until you do not see any air bubbles on the painting.

3 Place the Backing Paper

Clean any starch paste that falls outside of the painting with the paper towels. Now you are ready to put the backing paper onto the painting. Hold the rolled-up backing paper in one hand and align it with the two edges of the Plexiglas. The painting is now actually on the center of the backing paper because it is 2 inches (51mm) smaller than the backing paper. Use your other hand to lightly press down a little portion of the backing paper onto the painting.

4 Unroll the Backing Paper

Slowly unroll the backing paper while pressing the paper towel roll onto the painting. At this stage you should not lift up the backing paper even if you make a mistake, otherwise you may destroy your painting.

5 Secure the Backing Paper

Now the backing paper is attached to the entire painting. Use the paper towel roll to press together the painting and the backing paper a few more times so that they attach to each other firmly.

6 Apply Paste to the Corners

Use the flat brush to apply the starch paste on all four edges of the backing paper. Do not spill it on any area of the painting.

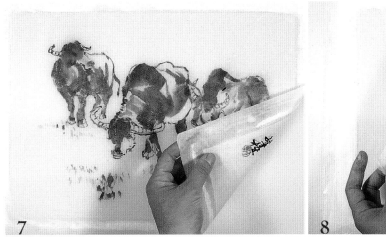

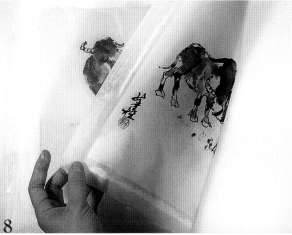

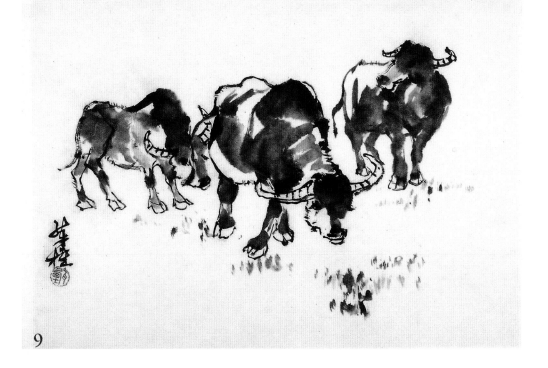

7 Lift the Backing Paper and Painting
Lift up both the backing paper and the painting with your hands; try one corner at a time. Sometimes you can lift them on the first attempt, but other times you may have to try all four corners.

8 Continue Lifting Off the Plexiglas
Continue using both hands to lift the backing paper and the painting with until they are off the Plexiglas.

9 Allow Your Painting to Dry
Attach the four edges of the backing paper to a plywood board or a wall. It is like putting a poster up on a wall. Let the painting dry at room temperature. It will take a few hours to a half day for it to completely dry, depending on the humidity.

Once the painting is dry, use a knife or a blade to cut the four edges of the backing paper at about ½-inch (12mm) from the painting. You can see that the painting is not only flat, but also looks better because the backing paper provides a white background that enhances the colors and ink. Now your painting is ready for matting and framing just like a watercolor painting.

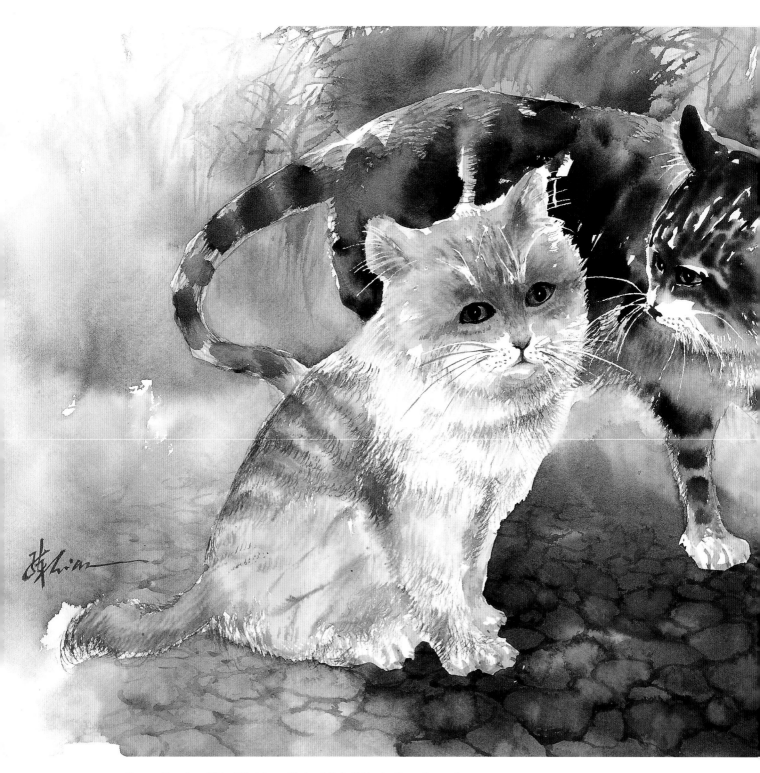

CATS *Watercolor 11" × 15" (28cm × 38cm) 140-lb. (300gsm) cold-pressed watercolor paper*

CONCLUSION

When you finish reading this book you may be excited to practice the techniques. If you have never tried Chinese painting, you should start with the basics of holding the brush, loading the brush with several colors, blending the ink and controlling the water. Practice on small Shuan papers and paint simple objects. Of the two Chinese painting styles, you should learn detail style first then move to spontaneous style. In many paintings, the more simple and easy it looks, the more difficult it is to paint.

My watercolor paintings are influenced by Chinese painting techniques and theories. If you are a watercolorist you can learn a lot from Chinese painting too, especially from spontaneous style. It is important to be relaxed when you paint. Do not put any pressure on yourself. If you get it, you should be happy. If you don't, you shouldn't be disappointed. Just throw the painting away and start another one later. I trashed many more paintings than I kept at the beginning.

I had never thought about making art my career—I used to be a doctor and an architect—yet now I am a full-time artist. I love painting, learning from artists and practicing as often as I can. I am happy to share my painting techniques with you. Even though I am not a physician who saves patients from suffering, I am happier because I can bring happiness to you and others through my paintings.

INDEX

RESOURCES

Zhen Studio
P.O. Box 33142
Reno, NV 89523
Phone: (510) 685-2654
e-mail: lianzhen@yahoo.com
website: www.lianspainting.com
The Chinese painting materials used for this book are available from Lian Zhen. Send a letter or an e-mail to him with your inquiry.

The following two art suppliers carry Sumi painting materials including Sumi paper, brushes, ink stone, ink stick and bottle ink. These materials are OK for amateur artists in Chinese painting.

Jerry's Durham
PO Box 58638
Raleigh, NC 27658
Phone: 1-800-827-8478
website: www.jerrysartarama.com

Cheap Joes Art Stuff
374 Industrial Park Drive
Boone, NC 28607
Phone: 1-800-227-2788
website: www.cheapjoes.com

THE BEST IN FINE ART INSTRUCTION
IS FROM NORTH LIGHT BOOKS!

Dory Kanter's inspirational guidance is perfect for both beginning and experienced artists alike. *Art Escapes* gives readers a fun, easy-to-execute plan for building an "art habit." Inside, you'll find daily projects for drawing, watercolor, mixed media, collage and more. With *Art Escapes*, you'll experience heightened artistic skill and creativity, and find the time to make a little bit of art everyday.

ISBN 1-58180-307-9, HARDCOVER W/CONCEALED WIRE-O, 128 PAGES, #32243-K

This book is for every painter who has ever wasted hours searching through books and magazines for good reference photos only to find them out of focus, poorly lit or lacking important details. Artist Bart Rulon has compiled over 500 gorgeous reference photos of majestic animals in their natural habitat, all taken with the special needs of the artist in mind. Five demonstrations by a variety of artists show you how to use these reference photos to create gorgeous wildlife paintings!

ISBN 1-58180-166-1, HARDCOVER, 144 PAGES, #31922-K

Take advantage of the transparent, fluid qualities of watercolor to create startling works of art that glow with color and light! Jan Fabian Wallake shows you how to master special pouring techniques that allow pigments to run free across the paper. You don't need to worry about losing control or making mistakes. Wallake empowers you to trust your instincts and create glazes rich in depth and luminosity.

ISBN 1-58180-487-3, PAPERBACK, 128 PAGES, #32825-K

These books and other fine North Light titles are available from your local art & craft retailer, bookstore, online supplier or by calling 1-800-448-0915 in North America or 0870 2200220 in the United Kingdom.